D0396613

Who's Afraid of Contemporary Art?

Who's Afraid of Contemporary Art?

An A to Z Guide to the Art World

Kyung An and Jessica Cerasi

With 40 illustrations

 Thames & Hudson

On the cover:
Daniel Arsham, *Wrapped Figure*, 2012. Fibreglass, paint, joint
compound, mannequin, 198 × 249 × 38 cm (78 × 98 × 15 in.).
Photograph Daniel Arsham. Image Courtesy of Daniel Arsham
Studio

First published in 2017 in hardcover in the United States
of America by Thames & Hudson Inc., 500 Fifth Avenue, New York,
New York 10110

www.thamesandhudsonusa.com

Library of Congress Catalog Card Number 2016941846

ISBN 978-0-500-29274-7

Printed and bound in Malaysia by Times Offset (M) Sdn. Bhd.

Contents

Who's Afraid of Contemporary Art?

THIS BOOK HAS ITS BEGINNINGS in the many awkward conversations we shared with friends and relatives while showing them round our first curatorial endeavours. Even though they were impressed by our first museum jobs, we were met with vacant stares and wry smiles when we tried to explain the stresses of our work, from getting the permits to install a column of human fat in an exhibition (yes, really) to the horror of coming into the gallery and finding the cleaner had thrown one of the artworks in the bin (also true). To friends and family outside the art world, being a curator seemed to boil down to deciding on the cleverest way to hang paintings in a room. They were all baffled, alienated and more than a little amused by it all.

The questions that form this book have come up time and time again, and are those we feel best illustrate people's frustrations with contemporary art. They are perfectly reasonable questions, but ones that many are still too afraid to ask and that the art world generally fails to address in a way that can be easily understood. We've narrowed them down to a list of twenty-six, with a chapter for each one. They range from questions about contemporary art to ones concerning the wider art world that surrounds it. Our aim is to introduce new ways of thinking about contemporary art by answering them in a way that is easy to digest – the A to Z format, like a map, is there to help navigate this terrain.

Each chapter consists of a text that addresses the question and provides an overview of the topic it introduces, followed by a section that spotlights a particular artwork, event or issue that strikes at the heart of the subject or comes at it from a different perspective. While every chapter is a standalone introduction to one aspect of contemporary art or the art world, they are also all linked in one way or another. We've sought to draw out those connections by referencing different chapters within the text, in the hope that readers find their own path through the book. After all, the production and interpretation of contemporary art are closely entwined with the art world, its systems and its history. To understand one, you almost always need to know about the other.

Who's Afraid of Contemporary Art brings together all you need to give you the confidence to hold your own in conversation about contemporary art...or to go to an exhibition and decide if you like it. If we can talk about topics as complex as the latest technology, an art-house film or the next general election casually with friends, then why does the idea of chatting about contemporary art fill us with so much fear? It is a specialist field like any other, and can lend itself to informal understanding and dinner party conversation in much the same way. We invite you to accompany us on this journey through all that the art world has to offer from A to Z, and hope that by the end you'll see that there's nothing to fear, and that contemporary art can be intellectually rewarding and great fun.

We would like to thank our friends and families for their desire to understand the things we are passionate about and also for their sheer cluelessness about where to begin, which inspired us to write this book.

Kyung An and Jessica Cerasi

Art, What For?
What's it all about?

WHAT IS IT THAT COMPELS millions of people every year to visit art museums → see Q? Why do people spend unspeakable amounts of money on art → see M? When did every city decide it needed a crazy-looking art gallery → see U? Why do so many students go to art school when the odds of making it as an artist are stacked against them → see D? And just why are so many of us drawn to all of this? In short, why do we care about art?

Because art can do things. At its most basic, it can offer a respite from the humdrum routine of everyday life, lifting us out of ourselves by inviting us to experience something out of the ordinary. But at its best, it is incredibly ambitious. It prompts us to think about life's bigger questions, shows us our preconceptions and challenges assumptions we might never have known we had → see O. And when it works it can be tremendous, appealing to our emotions and tapping into a shared consciousness among people with differing life experiences.

In an era when conflicts can escalate so quickly and political thinking can be so polarized and entrenched, art can offer an opportunity to question, provoke and imagine; it can stimulate debate and encourage conversation with others. It is able to do so precisely because it does not prescribe one point of view, but allows for multiple meanings to emerge → see K. In showing us that things can be approached from many different perspectives, art, by its very nature, challenges the status quo. It shows that things don't have to be the way they are, and this makes art a driving force for change → see R.

Like our contemporary world, today's art is not fixed, but always shifting and growing. Contemporary art articulates our present. It offers us an opportunity to process our experience alongside today's artists and make sense of today's world with them → see Y. Describing her role as an artist, the photographer Catherine Opie, known for her images of the communities and landscapes of contemporary America, explained: 'One of the reasons that I have been driven to the idea of creating moments

of representation of my time is not only finding myself within that, it's also this unbelievable human need.'

Like our contemporary world, today's art is not fixed, but always shifting and growing. Contemporary art articulates our present.

It is this ceaseless drive to question and to understand that makes great artists so inspiring and fascinating. For virtually any artist who survives the tests of the art world, making art is a compulsion, a way of making sense. Whether their motivations come from working through personal experiences, or their goals are more outward-looking and political, making art takes courage. At the end of the day, to make an artwork is to put a piece of yourself out into the world, at the risk of judgment, and to proclaim your thoughts as worthy of attention. Making art is about embarking on a course of action without knowing quite where it will end up, without fear of failure or any guarantee of reward. That takes guts. It is these risk-takers to whom we owe all the extraordinary art that inspires us. So as we set out on this journey through the art world, let's not forget the words of legendary art historian E. H. Gombrich: 'There is no such thing as art. There are only artists.'

From idea to artwork

ALTHOUGH WE THINK OF ART as the creation of an artist, the truth is, it often takes hundreds of people to make art happen. Yes, it's the artist who generates the idea, but bringing those ideas to fruition and to an audience involves a whole host of people along the way.

Take the work of Ghanaian artist El Anatsui, for example. Anatsui is well known for his large-scale sculpted metal wall-sculptures, created using thousands of bottle caps sourced from local recycling stations. At his studio in Nsukka, Nigeria, Anatsui works with an extensive team of assistants to fold, crumple, crush and carefully stitch the bottle caps together into intricate and colourfully patterned sculptural hangings.

As a matter of principle, Anatsui does not provide installation instructions, so these works take on radically new shapes with each installation. There isn't any one particular way each of his works should be installed; rather they can respond to the particularities of the space in which they are exhibited. In one venue, they may be hung from the wall, in another folded or placed on the ground; once, some works were even draped over a hedge when they were shown in a garden. These decisions of display will be taken in tandem with the installation team, which includes curators and conservators who can advise on optimal ways to show the work → see J, → see T. Lifting these heavy and delicate wall-hangings requires a team of trained art handlers, as well as a few scissor lifts. Achieving the rippled effect of drapery is a complex process involving technicians schooled in a special system of supports and fixtures. And let's not forget all the staff at the museum where the work is shown → see Q and at the galleries who make the sales to fund its production → see N.

At the end of the day, it's all about teamwork. Whether the artist works alone with a paintbrush or with a production crew to make an idea come alive, there's no escaping the fact that it takes an entire art world to share it with everybody else.

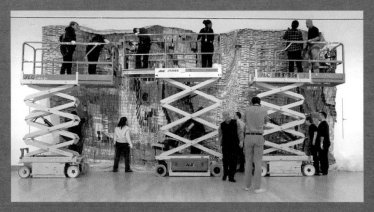

Art handlers installing El Anatsui's *Earth's Skin*, 2007,
at the Brooklyn Museum, New York

Bringing You Up to Speed
How did we get here?

QUESTIONS SUCH AS 'WHAT IS ART?' or 'How did it become what it is today?' are difficult to answer, not least because art has always meant different things to different people. Throughout history, each era has posited its own answers, indelibly shaping our interpretations today. If we are to make sense of contemporary art, we need to look at how we got here.

For centuries, art was created by a handful of celebrated geniuses and countless unknowns, usually in the service of a powerful patron – a monarch, religious sect, the state or the wealthy. Whether it was made to illustrate the word of God, record a historical moment, capture the face of a beloved or simply to show off your wealth, art was created primarily to serve a purpose and then to be appreciated.

It was only in seventeenth-century Europe, with the onset of the Enlightenment, that the idea of art as we know it now came into being. As intellectuals used reason to challenge existing systems of ethics, government and religion, artists sought to emancipate art from the need to instruct, delight or moralize. This gathered momentum in the nineteenth century, when the French art critic Théophile Gautier (1811–1872) began to promote the notion of 'art for art's sake', arguing that art had its own inherent value and should be assessed without reference to history, politics, morality or religion. This changed how we make and understand art forever.

As soon as artists dared to question what art had always been, a whole wealth of possibilities opened up. Modern art was born as artists began to reject the styles of the past in order to create works inspired by modern society. This new art reflected the radical developments in technology, transportation and industry, as well as their unprecedented impact on the socio-economic and cultural conditions of the time. Over the past century, the ways in which art is made have expanded rapidly to include complex configurations of indeterminate materials → see T; moving images → see G; performances → see S; and ideas → see I; in addition to traditional oil on canvas, ink, marble and bronze. Thanks to the

B

efforts of various pioneers, art has been able to break free from age-old constraints on how it should look and the topics it should address.

It's important to remember that art did not get here by chance. Artists of all eras are products of their time and culture; the changing conditions of their surroundings have been instrumental in pushing art to become what it is today. For instance, it was eighteenth-century industrialization and technological advancement that gave birth to the camera in the nineteenth century. Photography soon eclipsed painting's age-old role of depicting the world as it is. But it was almost a century before people shook off the idea that photographs were merely visual documents and photography was accepted as a medium for artistic expression. More recently, the Second World War, the Cold War, the invention of the Internet, post-colonialism and the onset of globalization have permanently affected the way we make, think and talk about art. These developments opened our eyes to the fact that there isn't just one story of art, but as many histories as there are cultures → see H.

> Artists of all eras are products of their time and culture; the changing conditions of their surroundings have been instrumental in pushing art to become what it is today.

And here we are today. Contrary to what some might claim, contemporary art has not abandoned its past. Patronage still exists in one form or another, artists are still highly skilled practitioners and art history is still tremendously important to the making of art. However, the art world is much more expansive and the field of art history much broader than ever before. So now that we've set the scene, let's dive into the contemporary! Isn't it time to see what all the fuss is about?

Contemporary before contemporary

THOUGH ITS PROPENSITY to break the rules might have you thinking otherwise, contemporary art isn't some wacky destructive credo that sets out to crumble all that has come before. Artists and curators are always looking back at artists from the past, who followed similar lines of enquiry and whose creative responses might somehow inform or reflect their own.

Not only the creator of Mona Lisa's mysterious smile and the magnificent *Last Supper* (1495–98), Leonardo da Vinci was also a pioneer in science, mathematics, anatomy, botany and astronomy. His desire to accurately depict human anatomy and movement led him to unprecedented methods, such as dissection, a practice that was strictly illegal back in the fifteenth century. Truly a Renaissance man, da Vinci did not see science and art as separate pursuits, and he was obsessed with the new scientific and engineering developments of the era. His multidisciplinary approach, experimental spirit and unwillingness to compromise are echoed in the outlook of many artists working today.

Similarly, Spanish court painter Francisco Goya responded closely to the issues of his times in a number of works that have a strong resonance for artists working with social and political critique today → see R. Goya is now best known for a series of prints only exhibited after his death: *Disasters of War* (1810–20), his response to the Peninsular War of 1808–14. These depictions of mutilation, torture and rape are powerful commentaries on the impact of conflict on ordinary people and reflect the artist's disillusionment with Spanish politics. His painting likewise turned to a darker subject matter towards the end of his life, as his psychological and physical state deteriorated. Goya's *Black Paintings* (1819–23) illustrate his growing bitterness towards society and offer expressive and intimate responses to the turmoil of the period.

After all, even before the term 'contemporary art' became so ubiquitous → see C, every historical period had its own 'contemporary' artist. Looking back, it's fascinating to see that this art that may seem so antique still has so much resonance with our present time and contemporary art practice.

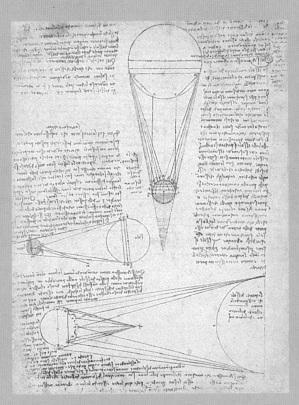

A page from Leonardo da Vinci's *Codex Leicester*, 1510,
a collection of scientific writings that includes reflections
on astronomy, fossils, air and water

Contemporary
What makes it
so contemporary?

WHAT DO WE MEAN when we talk about 'contemporary' art? A hazy impression might spring to mind: something recent, probably unintelligible. But how do we actually define the contemporary? Is it the art of the last ten, twenty, fifty years? Does something stop being contemporary when the artist dies? Or when the work starts to look outdated? The fact is, there isn't a hard-and-fast rule here.

The notion of 'contemporary' art dates back to the 1930s when Modern Art was first defined as a movement – just like that, much avant-garde 'modern' art that had broken with tradition ceased to be 'contemporary'. Ever since then, the 'contemporary' has been a band of time anchored in the present, always moving forward and leaving history in its wake.

But how far back does it reach? Historians tend to agree that a significant break point occurred in the 1960s and 1970s with Pop Art; Minimalism → see E; performance → see S; and new media art → see G all coming to the fore at the same time. That period marked a moment when artistic development could no longer be described as a coherent succession of movements and artist groups. No longer could art's cutting edge be easily located in one city, among one group of people; it was in many places at the same time – the 'global village' was born.

Artistic production is now so diverse, so varied, that any number of tiny movements can be established and disbanded with each new exhibition concept. And this may be one of the reasons why 'contemporary' has come to stand in for more specific terminology or more defined artistic movements. This one word conveniently absorbs the multiple forms art takes today into one category. Lucian Freud's portraits; Jeff Koons's balloon sculptures → see M; Marina Abramović's performances → see S; and Joseph Kosuth's concepts → see I – they all fall under the umbrella of this ever-expanding framework.

In this sense, the 'contemporary' might be thought of as a thematic categorization rather than a purely temporal one. Because, while time constraints are useful in establishing

C

boundaries, nine times out of ten we know 'contemporary' art when we see it, not when we check the label. It is art that speaks to our globally influenced, culturally diverse and technologically advancing world.

While time constraints are useful in establishing boundaries, nine times out of ten we know 'contemporary' art when we see it, not when we check the label. It is art that speaks to our globally influenced, culturally diverse and technologically advancing world.

Interpreting the present moment is seldom an easy task, and making sense of today's world requires innovative techniques and new approaches. Artists frequently draw upon whatever media they feel illustrate their ideas most appropriately, whether painting, sculpture, film, photography, performance or new technologies. Ideas, political concerns and emotional responses may take centre stage over aesthetic execution → see I. In fact, much of the art of the past few decades has either been connected with a particular issue (such as feminism, AIDS awareness or land use), or explored the human condition as a kind of applied philosophy. Indeed, by inviting us to contemplate and reflect on the world we live in and the issues we face, today's contemporary art possesses an acute social conscience → see Z. There are more artists working with social issues than ever before, responding to the ways our present is shifting. As the world moves forward, our opinions evolve and our outlooks change, so too does 'contemporary' art.

Tino Sehgal,
This is So Contemporary,
2005

IMAGINE WALKING into an art museum, casually minding your own business, when suddenly three gallery attendants leap at you out of nowhere. Waving their arms around, waggling their fingers and quivering all over, they circle you and chant in a sing-song voice: 'Oh, this is so contemporary, contemporary, contemporary.' Before you have the chance to get your head around the fact that they aren't actually museum guards, they return to their original positions and announce with a little dance flourish, 'This is so contemporary!' Well, is it?

How can we tell? What is it anyway? Well, we know it's not a performance – Tino Sehgal shuns the term. The participating people, who range from museum trustees to children, are called 'interpreters' not 'performers', since 'performance' evokes the presence of a traditionally passive theatre audience. Instead, Sehgal describes it as a 'constructed situation' that interrupts the conventional flow of a gallery visit and invites participation from individuals. It is also resolutely not an object. In place of an object, he presents us with a game and a set of rules that allow meaning to arise from the exchange between the interpreters and the chosen visitor. Sehgal thinks there's too much stuff in the world anyway and his pieces don't involve any material, ever → see I. That means no written instructions, no catalogues and no pictures. If you want to buy his work, there will be no contract or paperwork. You just have to take his word for it in the presence of a notary.

So, is it so contemporary? Of course! In 2005 the art world may not have been ready for Sehgal's dancing gallery attendants, but, looking back, the outrage it initially provoked feels out of place. *This is So Contemporary* seems to belong as naturally to the world of contemporary art as a stack of bricks or a can of shit → see E. Like many works of contemporary art, it continues to break the rules and change the nature of the game, proving that contemporary art is able to push boundaries and regenerate ceaselessly, always remaining 'oh, so contemporary'.

Tino Sehgal does not permit his works to be photographed

Dream Academy
How do art students become artists?

WE ALL KNOW you can't teach someone to be an artist. Or can you? Every year, hundreds of art schools all over the world welcome flocks of students from far and wide. But what exactly happens during those years at art school? How do art students become artists?

Not all artists go to art school, of course, but for many the trajectory is to enrol in a Bachelor of Fine Arts (BFA) degree. As with any profession, choosing the right school is crucial as each has its own reputation and traditions. Some art schools have distinct disciplines such as 'painting', 'sculpture', and 'video and new media' that you decide on from the get-go, while others promote a more holistic learning environment under the umbrella of 'fine art'. Either way, the curricula usually follow largely the same pattern.

At the heart of it all is studio practice. Each student is given their own section of studio space and it is from this little corner that they try things out, think through ideas and develop their practice. Although there is a heavy emphasis on the degree show (an annual show of graduating students' work), students also participate in smaller-scale 'interim' exhibitions a few times a year. These shows punctuate the academic calendar and serve as much-needed deadlines to motivate students to finish artworks. Not only are they an opportunity to test art out on an audience, but they are also a chance to learn how to work together and organize an exhibition.

We might be forgiven for thinking that all art students do is make art, but for an undergraduate, a typical day may well be filled with writing essays and going to classes. There are art history and theory classes, which encourage students to see that understanding what came before can help them to have a better grasp of their own practice (where did I come from?) and to figure out how to make their own unique contribution to the field (what do I have to say?).

Then there are the group critiques. Held regularly throughout the term, 'crits', as they are known, have students present their current work to their supervisor and a small group of fellow students, who mercilessly discuss and dissect each other's artistic work and ideas. It's not called a 'critique' for nothing. But as they pick up

the last remaining scraps of their self-belief, the students learn to defend, rethink and develop their own ideas. The supervisors, often practising artists themselves, are on hand to guide the conversation and can suggest artists, writers, artworks or whatever else might help students take their practice to the next level.

Understanding what came before can help students to have a better grasp of their own practice and to figure out how to make their own unique contribution to the field.

But what happens after graduation? By this stage, many students may already have one foot in the professional world, working part-time as artist's studio assistants or freelance art handlers, for instance, and they may continue to support themselves financially this way as they focus on their practice. Others will opt for a Master of Fine Arts (MFA) degree. At this level, there is a pronounced emphasis on independent research, with students encouraged to spend more time in their studios and granted greater freedom to opt into classes as they choose. This culminates in another degree show and a written dissertation that situate their artistic vision within the context of contemporary art and criticism. MFA degree shows are a big deal as they draw in collectors, gallerists and curators alike. For a budding artist, it's a chance to debut the result of two years' work to an art-world audience.

It may sound like a cliché, but art school is not a means to an end; it's a beginning. And in this sense, it's no different from other higher education institutions. Once you are done, ready or not, you are flung into real life – and that's when you really learn to be an artist.

Interns

EVEN IF YOU HAVE KILLER GRADES and a degree in art history or curating, the chances of getting a job in the art world straight out of university are very slim. Students with postgraduate degrees often still need professional experience if they want to pursue their dream job and it is now commonplace to see undergraduates working part-time as interns during the academic term. Internships have become a rite of passage for many seeking a career in the arts. And by that we mean in virtually every profession, from curating or art-book publishing to working in a gallery or managing a studio.

Internships, paid or unpaid, can last anywhere between several weeks and a few months. While a day in the life of an intern might be packed with administrative tasks, in many cases, interns are charged with huge responsibilities, whether overhauling an artist's archive, coordinating all the labelling for an exhibition or organizing image rights for a catalogue. There is no doubt that the art world relies heavily on interns for essential support.

Such dependence on the eagerness of interns to gain experience at whatever cost, especially in such a competitive field, has led to cries of exploitation. Thankfully, unpaid internships have become less common, but in the same stroke many former internships have been downgraded to non-business-critical 'volunteer opportunities'. There's also anxiety across the industry as budding professionals rack up endless lists of internships before they land their first job.

Nonetheless, it is undeniable that internships can be tremendously valuable experiences. Landing that coveted summer internship at a big-name museum or gallery can be a crucial step towards getting that dream job and it can help young people figure out if certain areas of the contemporary art world are right for them. Internships are also a great way to build connections. Friendships formed at these placements can offer a solid network that lasts a career, as the next generation of art devotees climb the ladder together.

'So, as a creative solution to our budgetary problems, our unpaid intern has kindly agreed to become our chief curator.'

Pablo Helguera, *Unpaid Chief Curator* from the series *Artoon*, 2008–present

Emperor's New Clothes
What makes it art?

WHEN MARCEL DUCHAMP submitted a urinal signed 'R. Mutt' to the salon of the Society of Independent Artists in New York in 1917, the committee rejected it on account of it not being art. Duchamp's presentation of a readily available, mass-produced object as art was simply preposterous. This 'readymade', as he called it, flew in the face of the centuries-old idea of the artist as a skilled creator of uniquely crafted, handmade objects.

Much of our understanding of art today is shaped by this notion of fine art as a master craft, a skill and dexterity with line and form refined and honed, and to be admired. And it is the perceived lack of skill involved in much contemporary art that gets people riled. Yet, as video, photography → see G and performance → see S become ubiquitous in museums, it is clear that this type of skill is no longer a prerequisite for the acceptance of a work into the annals of art history.

In fact, the question is far more interesting when we move from 'Is it art?' to 'When can something become art?' When Carl Andre presented a neat rectangular stack of 120 bricks on the floor of an exhibition space in 1966, the gallery context and its authority elevated these lowly objects to art. However, it's not as simple as that. Andre's *Equivalent VIII* is more than just a pile of bricks when we consider it as an attempt to challenge the traditional notion of sculpture in the history of art. At the time it was conceived, he and other like-minded sculptors in the US were interested in freeing sculpture from the expectation that it had to represent something. Labelled Minimalists together with their painter friends, they pared their works down to geometric shapes and simple colours, zoning in on the medium (what it's made of) and emphasizing basic forms. Both by taking the artwork off the plinth, the traditional means of displaying marble and bronze sculptures, and by presenting something as ordinary as a pile of bricks as art, Andre consciously positioned his work against the art that had come before.

While the gallery context can help to define something as art, it doesn't close the discussion. The next question to consider is, 'Do I believe it's art?' In order to answer this question, it is vital

to see that an artwork is a proposition. It is an invitation to view something as art, as more than the sum of its parts – to see something in a new light and assess it according to different parameters. An artist believes the work is art and the strength of that intention can compel the viewer to draw meaning from it, whatever that might be.

> **An artwork is a proposition. It is an invitation to view something as art, as more than the sum of its parts.**

Ultimately, it is for each visitor to decide whether or not to call out the emperor's new clothes. If we can put aside the impulse to question if something is art, it's easy to see that getting bogged down in such a line of questioning can only mean neglecting to engage with the artwork itself. After all, our perception of art changes just as our values and realities do, and what was deemed insignificant by one generation might suddenly speak volumes to another. At any rate, for virtually anyone working in the art world, the 'Is it art?' question is boring and irrelevant. The real question is: 'Is it any good?'

Piero Manzoni,
Artist's Shit, 1961

THIS WORK BY PIERO MANZONI claims to be exactly what it says on the tin:
Artist's Shit, contents: 30 gr net freshly preserved, produced and tinned in May 1961

In 1961, over the course of a month, Manzoni produced ninety such cans as a numbered edition, each one verified with the artist's signature as a seal of authenticity. Pitched at a global market with the monogrammed label in four different languages, they were priced at the value of their weight in gold. These days, they are worth far more. In fact, this work has continued to attract public attention, provoking a storm of controversy every time a major museum collection purchases a can for a six-figure sum.

You might think this is a joke and that's half the point. Manzoni was making fun of the art market and what collectors expect from artists. In the same year, he wrote: 'if collectors want something intimate, really personal to the artist, there's the artist's own shit, that is really his.' The creative process becomes a bodily one – a question of packaging, marketing and re-branding natural abilities. For Manzoni, the art object is intimately bound up in the broader mechanisms of consumerism and commodification. The end product is glorified with an aura typically reserved for works of art that epitomize the pinnacle of human achievement or for high-end commercial products. It is something truly authentic, imbued with a certain uniqueness – an unprecedented proximity to the artist that distinguishes it from generic, inferior versions created by you or me.

This all begs the question: is this highly prized commodity actually in the tin as sold? At such a price, you wouldn't want to ruin it by opening the can to find out and this uncertainty adds a further layer of irony. It's either full of shit or it's empty, so does it really make a difference whether or not there's anything in the can? Not really. The point is that you buy into the illusion and the mystique. More than fifty years on, Manzoni's *Artist's Shit* remains as poignant and witty a critique of the nature of the art market and its absurdities as ever. Same old shit.

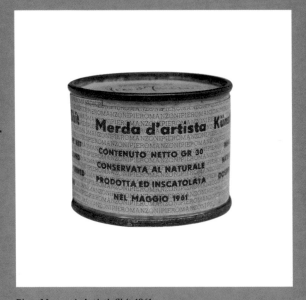

Piero Manzoni, *Artist's Shit*, 1961

Flashmobs
What's next in the art world calendar?

FROM VENICE TO SYDNEY, and London to Hong Kong, artists, curators, gallerists, journalists, celebrities and art students flock from megacities to the remotest locations to keep up with the latest in art. If you work in the art world, your annual calendar will most certainly revolve around the main art fairs and biennials, which have, in the span of just a few decades, become some of the most important and high-profile sites for contemporary art.

A 'biennial' (or 'biennale' – same thing) is a relatively new genre of large-scale international exhibition that takes place every two years in various venues across a city over the course of a few weeks or months. This is generally the brainchild of an invited curator (sometimes referred to as the artistic director), who oversees the selection of works and new commissions, as well as programming related talks, performances, workshops and publications.

Biennials are key forces in bringing the art world together in one place to take stock of the state of contemporary art. And while from the outside they might appear very similar, each is born out of its own historic, cultural and geographic circumstances: Documenta (1955–) emerged in Kassel as a cultural voice for post-war Germany (this one takes place every five years); Gwangju Biennale (1995–) arose from the democratization of South Korea; Johannesburg Biennial (1995–97) commemorated the end of apartheid. By confronting issues such as politics, race, identity, globalization and post-colonialism, these ambitious undertakings are intended to open up a space for social critique.

Art fairs occupy an equally important position within the art calendar. Commercial galleries, big and small, fly all over the world to showcase their new finds and old favourites, while collectors descend to discover younger, hotter artists from across the globe. Like biennials, art fairs have become international events. Art Basel now also operates fairs in Miami and Hong Kong → see N, while Frieze Art Fair welcomes visitors twice a year, once in London and once in New York. Though buying and selling are the driving forces of these events, they also offer tours of hard-to-

access private collections and artists' studios for VIPs, lectures by well-known curators and intellectuals, as well as showing temporary works and performances, all together making them that much more exciting and completely unmissable. The fair schedule is also crucial for local institutions and artists, who carefully time their exhibitions and events around the fair to ensure maximum exposure.

> **If you work in the art world, your annual calendar will most certainly revolve around the main art fairs and biennials.**

The significance of these endless biennials and fairs goes far beyond the events themselves. These platforms reflect the explosive opening up of art's circulation, geographically, economically and intellectually, which has helped a new generation of artists to become known internationally. They have also offered an opportunity for cities to raise their cultural status, providing the impetus for them to build more permanent structures and fuelling local artistic activities → see U. However, demanding schedules and travel plans mean that critics and curators rarely have more than a few days to see, absorb and pass judgment → see L. After all, this is as much a time to network with peers and woo collectors as it is a place to see art. Biennials in particular have faced criticism for their failure to connect with local communities long-term due to their temporary nature and the international audiences they court, while art fairs are often maligned for an emphasis on spectacular, flashy, saleable art.

With the art calendar moving constantly forward and on to the next, biennials and fairs enable the art elite to remain forever up to speed. So next time you find yourself in sunny Miami in December, don't just hit the beach – pop into the nearby fair and see what the fuss is all about.

Venice Biennale

Founded in 1895, the Venice Biennale, dubbed the 'mother of all biennales', is one of the most important events in the art world. For artists, the Biennale can be a moment of recognition and critical acclaim, a chance to debut on an international stage. For curators, it is a platform for challenging existing ideas about and approaches to art, while for the rest of the art world, it is an opportunity to see a multitude of artists' work in one spot.

The Biennale is made up of exhibitions at national pavilions and a large-scale exhibition organized by the Biennale's director, alongside a programme of collateral events. Each national pavilion is organized independently by a commissioner, who selects an artist or a group of artists to represent their country that year. Thirty countries own purpose-built permanent structures, which are dotted around the famous Giardini, a parkland area on the eastern tip of Venice. In recent decades, the number of countries exhibiting at the Biennale has grown rapidly. Due to lack of space, many have taken temporary venues outside the Giardini, spreading out across the various islands of the city. Each one stands as a testament to globalization's impact on contemporary art and the art world.

The Giardini also includes a large exhibition hall that presents one part of the themed International Exhibition, which is curated by a director appointed specially with each edition of the Biennale. The second part is held in the nearby Arsenale, a complex of former shipyards and armouries that also hosts some of the national pavilions. The choice of artistic director is always a hot topic in the art world, since it is probably the most prestigious curatorial role around. It is no wonder that this curator's name almost always becomes synonymous with that year's Biennale (so-and-so's Biennale). The chosen candidate leaves his or her mark, challenging visitors to think about art in a different way.

Every two years, the Venice Biennale offers the perfect excuse for tourists, locals and arts professionals alike to come together in the months of May through to November and eat spaghetti, drink Aperol Spritz and enjoy what the world of contemporary art has to offer.

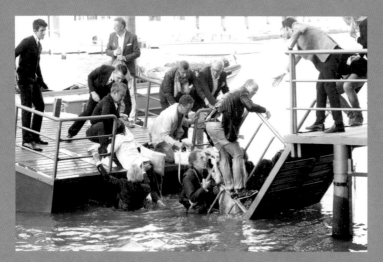

Visitors to the Prada Foundation at the Venice Biennale
in 2015 fall into the Grand Canal as a pier collapses

Geeks and Techies
When did it all get so technical?

ART AND TECHNOLOGY may seem the unlikeliest of partners, but throughout history technology has provided artists with new tools for expression. From Leonardo da Vinci's camera obscura (an optical device used as a drawing aid) in the fifteenth century to the emergence of Internet art, technological advances have always played a pivotal role in shaping art and our understanding of it. However, over the past fifty years it is fair to say that we have become more aware of the close ties between art and technology.

Artists had been experimenting with moving images since the early days of photography, but only with the introduction of video were many artists able to adopt it as a medium. In the late 1960s and early 1970s, artists began making tapes, as video cameras became less expensive and more portable. Tape stock could be recorded over and played back instantly. This new freedom allowed much more scope for experimentation and spontaneity, and no longer required artists to plan out the end product scene by scene.

Video also proved the perfect medium for documenting performance art and the experimental practices that were emerging at the same time → see S. Artists were able to re-purpose a tool that stood for objectivity, accuracy, information and mass-communication, to investigate concepts of surveillance, and the boundary between public and private. Moreover, here was a medium that had a running time and required viewers to watch it and lend it their attention in a different manner from a traditional art object. In this way, video art completely changed the exhibition experience. The new medium burst open a Pandora's box of questions: what happens to the concept of artistic authenticity and originality when artworks are digitally manipulated? How should this art be shown and stored → see T? Is this even art → see E?

Alongside experiments with video, a whole realm of new possibilities were quickly incorporated into art as other technologies and materials were developed. Soon artists were using technology as sculptural material (see Nam June Paik's television sets or Dan Flavin's use of fluorescent lighting tubes), and writing algorithms

G

and coding to generate a new digital aesthetic (see Manfred Mohr's randomized drawings made with one of the first computer plotters or JODI's online drawings in HTML code in the early days of the Internet). More recently, a generation of artists has begun working with 3D printing, social media and computer gaming. To encompass this broad spectrum of work, which would not have been technically possible fifty or sixty years ago, the phrase 'new media art' has evolved as a catch-all term. This is ironic, given much of this media is not all that new and artists have always adopted the newest tools and materials available to them. Indeed, the term is problematic precisely because it can stand for everything and therefore nothing; its ever-expanding scope speaks to our difficulty in keeping pace with technology.

Throughout history technology has provided artists with new tools for expression.

Such developments have also transformed how we view and interact with contemporary art today. The digital age has fundamentally changed the ways in which art is created, circulated, marketed and supported, reflecting the world's transition into an ever more connected society → see Y. Nowadays, images and texts on art can be accessed in a matter of clicks from the comfort of your own home, while artists are able to crowdsource money for their projects and sell works directly to the public online without the need for a gallerist.

In an era when technology has radically shifted our relationships to people, time and geography, art that is truly contemporary must reflect these changes. In fact, can there be a more compelling way for art to reflect our complex times than by embracing and understanding the media of our age?

Internet art

THE BIRTH OF THE WORLD WIDE WEB in 1989 heralded a new era of online communities that could exist outside of race and gender. Very quickly, this new 'cyberspace' became fertile ground for a wide variety of early 'net art'. Online, artists could create art that did not rely on the art market and gallery circuit, reaching audiences in their homes and offices with work that could be both produced and viewed on the Internet.

In the Web's earliest days, artists from across the world came together as online communities to exchange ideas and artworks virtually through web hosting and web art curating. With the dotcom boom in the late 1990s, many artists started to respond to the corporatization of the Internet. For example, etoy.CORPORATION (online since 1994), an online firm that describes itself as a 'corporate sculpture', is best known for a large-scale digital 'hijack', which involved infiltrating several major global search engines and replacing the top search terms with keywords including 'censorship', 'bondage' and 'porsche'. In this way, these artists sought to show that what most Internet users perceive as the natural structuring of content online was actually developed for and controlled by corporate interest → see R.

More recently, the access to an incredible wealth of user-generated information, first through blogging and then social media platforms, has given rise to a new form of artistic skill based on the ability to interpret, filter, select and curate existing content. At the same time, many artists are drawing attention to the physical structures that support the Internet, which is so often portrayed as a mythical 'cloud'. Evan Roth's Web-based series of Internet Landscapes traces the landing points of Internet submarine fibre-optic cables, showing the Internet to be a sprawling infrastructure of wires and servers that spans the globe. With so many new challenges and possibilities opening up, artists have only just begun to explore the manifold ways in which the Internet is reconfiguring our times → see Y.

Evan Roth, *http://s33.851850e151.244960.com.au*, from the series *Internet Landscapes: Sydney*, 2016

Histories
Whose story is
the story of art?

THE 'HISTORY OF ART', as many know it, opens with the Ancient Greeks and Romans, makes a few stops at familiar names like Michelangelo, Rembrandt and Picasso, then arrives at Andy Warhol's Campbell's tinned soup in New York, before it all gets a bit confusing. But who wrote this story about a bunch of white dudes anyway? Were there no women or non-white artists? Or was everything they did simply not very good?

These are just some of the questions that have prompted artists, art historians, curators and museums to challenge this history. Attempts to re-write this narrative to include women, non-white, non-Western and queer artists ultimately exposed the existing story of art to be a 'straight white boys' club'. It became obvious that writers of this history had relied on processes of exclusion and marginalization to further validate the existing order of relations between perceived opposites, such as man/woman, white/non-white, high culture/low culture and civilized/uncivilized. Art history was clearly on the side of the dominant class, gender and race, while all other art was carefully written out for being 'craft', 'primitive', 'passé', 'derivative', 'exotic' or just plain 'bad'.

The question at the heart of these efforts is: 'Whose story is this history?' One artist who has long engaged with this line of enquiry, through his art and curatorial practice, is Fred Wilson. On the occasion of his groundbreaking solo show at the Maryland Historical Society in 1992, a sign on the front of the building proclaimed that visitors would encounter 'another' history inside. The exhibition, 'Mining the Museum', in fact presented many of the museum's collections anew through surprising and satirical juxtapositions. One display under the title *Metalwork 1793–1880*, for example, showed an ornate silver tea service alongside a set of iron slave shackles from the same period. The tea service had previously been displayed in a section of 'silverware', but the shackles had never been shown before – these were not part of the 'history' told by the museum. Precisely by displaying these objects next to one another, Wilson showed how our systems

of classification can hide uncomfortable truths and that history is never just one story.

These are issues Wilson has explored further in his own art practice. *Guarded View* (1991) is an installation of black headless mannequins dressed in the uniforms of security guards from New York's leading art museums. These faceless mannequins place the figure of the guard – who is typically trained to be 'invisible' so as not to interrupt the viewing experience – front and centre. Wilson said that 'this work was really about having been to museums, going to museums for years, and noting that besides myself and the guards, and perhaps, the people in the food service or the maintenance, you know, we were the only African-Americans or people of color in the museum. And no one in the professional staff, who decides what gets put on display, how those things get described and discussed, what's acquired by the museum.' With this work, Wilson called attention to the systems of power – in this instance, of both class and race – that operate within art museums and society more broadly.

Attempts to re-write the history of art have exposed the existing story to be a 'straight white boys' club'.

Wilson is among many in the art world who have fought hard to insert black artists back into the narrative of twentieth-century art history. A number of leading American museums are now building on this effort and, thanks to dedicated scholarly research, acquisitions and exhibitions → see Q, African-American artists are slowly receiving long-overdue recognition. But this is just one of the ways in which art history has opened up.

Globalization has been a radical catalyst on this front. Buzzwords like 'transnationalism' or 'global art history' signal a shift away from the predominant 'Eurocentric' approach that

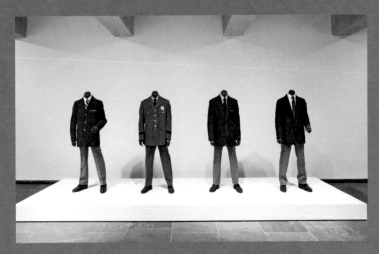

Fred Wilson, *Guarded View*, 1991

privileges European culture over other cultures. Exhibitions such as 'Magiciens de la Terre' (Magicians of the World) at the Pompidou Centre in Paris in 1989 have sought to address the problem the curator described as 'one hundred per cent of exhibitions ignoring 80 per cent of the earth'. In fact, the proliferation of large-scale international art exhibitions that bring together artists from diverse geographic and cultural origins has prompted new questions, such as: how should we understand similar works of art that emerge in different corners of the world at the same time? What happens when the art and culture of one nation is forced upon another through colonization? What does that mean in terms of influence and originality? How can we understand the impact of imperialism and capitalism on our evaluation of art and artists? Is it even possible to tell a history of art that takes into account all artistic activities worldwide? In short, is a global art history possible? It is this questioning of the status quo that unites the multiple voices that rally against the age-old story, however diverse their approaches or specific their agendas.

Although this is a brave undertaking, the battlefield is not without its pitfalls. The art world is frequently accused of including 'token' female artists or artists of colour to evade accusations of exclusivity or to fill quotas. Sweeping together various marginalized or minority groups under the blanket of 'multiculturalism', irrespective of their different histories and struggles, is equally problematic. This is a step in the right direction, but resurrecting forgotten figures or movements is simply not enough unless we are willing to re-think the narrative as a whole.

Will we ever be able to write a history that is truly representative of each artist's varied experience and embraces everyone's story? Maybe not. But ultimately, as Wilson has shown, new perspectives are not only possible; they are imperative. We must continue to probe, question and recalibrate: art history can only be the richer for it.

Guerrilla Girls

In 1989, an anonymous group of female artists calling themselves the Guerrilla Girls conducted a 'weenie count' at New York's Metropolitan Museum of Art, counting the ratio of male to female nudes in artworks on display. They found that, while less than 5 per cent of the works were by women artists, 85 per cent of the nudes were female. This begged the question: 'Do women have to be naked to get into the Met. Museum?'

The Guerrilla Girls describe themselves as 'feminist masked avengers in the tradition of anonymous do-gooders like Robin Hood, Wonder Woman and Batman', who wear gorilla masks in the fight against sexism, racism and corruption in art and popular culture. The group formed in New York in 1984 in response to the Museum of Modern Art's exhibition 'An International Survey of Recent Painting and Sculpture', which opened that year. The exhibition was the inaugural show in MoMA's newly renovated and expanded building, and was intended as a survey of the most important contemporary art and artists in the world. Of the 169 artists presented, only thirteen were women, prompting female artists to protest outside the museum. Since then, their unique breed of activism-as-art has taken on a variety of forms to combat sexism and racism within the art world, from organized protests to provocative and humorous posters, stickers and billboards.

One of their most famous posters, *The Advantages of Being a Woman Artist* (1988), wryly lists thirteen perks of being a female artist, such as 'Knowing your career might pick up after you're eighty', 'Having the opportunity to choose between career and motherhood' and 'Having more time to work after your mate dumps you for someone younger'.

Their quest to expose 'the overlooked, and the downright unfair' brought to light just how deeply rooted gender inequalities ran (and continue to run) in the (art) world. Armed with a couple of gorilla masks, some dry humour and a swathe of hard facts, this anonymous group of women has held the art world to account and prompted a critical overhaul of public collections and exhibition practices that continues today.

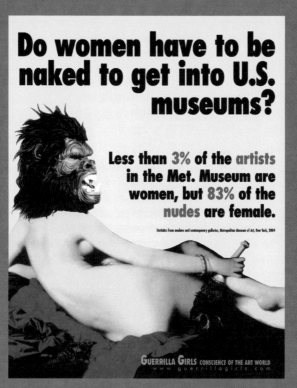

Guerrilla Girls, *Do women have to be naked to get into U.S. museums?*, 2005. The poster was updated sixteen years after the project first started in 1989 and the statistics were no better

It's the Thought That Counts
Can a concept be a work of art?

In 1967, the American artist Sol LeWitt wrote in leading art magazine *Artforum*: 'In conceptual art the idea or concept is the most important aspect of the work. When an artist uses a conceptual form of art, it means that all of the planning and decisions are made beforehand and the execution is a perfunctory affair.' The article was titled 'Paragraphs on Conceptual Art' and with that, this new art form was given a name.

'Conceptual Art' most commonly refers to a movement in the art of the mid-1960s through to mid-1970s, when artists in the USA, Europe and Latin America began experimenting with the premise that the finished object was secondary to the meaning it conveyed. Although Conceptual Art is often associated with a handful of artists in New York, it was far from a cohesive movement – more a concurrent flowering of similar tendencies in different corners of the world. Among the most heralded works of this period is Joseph Kosuth's *One and Three Chairs* (1965), which portrayed a chair in three different ways: an ordinary chair, a photograph of a chair and a dictionary definition of 'chair'. By demonstrating how the 'chair' derives meaning equally as object, image and words, Kosuth showed how an idea could exist independently from the object it represents and how one meaning could be represented in different forms.

Another way of doing this was by creating instructions as artworks, which allowed the work to take on multiple forms according to the guidelines provided. Sol LeWitt, for instance, began a series of 'wall drawings' in 1968, each of which consists of a certificate with written instructions and diagrams for others to execute. Because these instructions can be carried out by anyone, anywhere, at any time, these wall drawings look different depending on who implements the directions and the shape of the space. In another well-known series, Yoko Ono created paintings with instructions. For example, *Snow Piece* (1963) read: 'Think that snow is falling. Think that snow is falling everywhere all the time. When you talk with a person, think that snow is falling between you and on the person. Stop conversing when you think the person

is covered by snow.' Ono may have physically made the painting, but it is down to viewers to bring its meaning into existence by taking the steps to evoke her idea in their minds.

Conceptual Art has permeated our entire understanding of what contemporary art can be.

With the arrival of this radical notion – that something as simple as an idea could be art – the standards of aesthetics, skill and marketability by which art has so often been judged became much less important → see Z. In fact, this re-evaluation of the accepted definitions of art and of the value placed on it emerged at a time when artists were seeking to challenge the authority of art institutions and the market. Indeed, conceptual artists undermined the commodification of art with work that could not be easily bought and sold. Equally, the fact that the artist may never even be physically present for the making of the work overturned the traditional notion of 'the hand of the artist' as the marker for authenticity and value. Art no longer had to be made up of things, and this opened the way for everything, from musical scores to advertisements, to be considered on an equal footing with painting and sculpture.

Today, Conceptual Art has permeated our entire understanding of what art can be. That's why, in casual parlance, the term 'conceptual' has come to stand in for art that does not conform to traditional notions of composition and artistic skill. Indeed, the principal legacy of the Conceptual Art of the 1960s and 1970s has been to revive Duchamp's eminent proposition that art can truly be anything → see E. We might also credit Conceptual Art for the fact that so many artists working today feel free to switch from one medium to another, selecting the form most suited to the idea they are looking to convey.

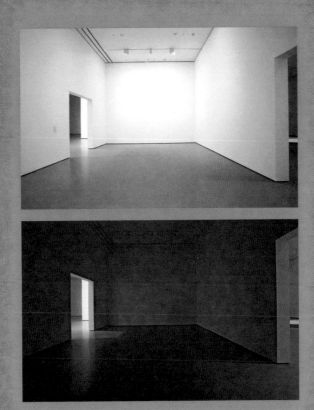

Martin Creed, *Work No. 227: The lights going on and off*, 2000

So what idea are we to take from a contemporary conceptual work such as British artist Martin Creed's Turner Prize-winning *Work No. 227: The lights going on and off* (2000)? → see L. As the title suggests, it consists of the lights in the exhibition space switching on and off again: five seconds on and five seconds off, repeatedly, forever. In essence, there is no content to the work. It simply intervenes with the provisions of the existing space, without adding anything. Creed has said that the work grew out of the desire to find a way to make art without 'making something extra for the world'. And that's exactly it! With one simple action, the ordinary viewing experience is disrupted completely and visitors are made more aware of the empty gallery and of themselves standing there searching for clues. Displayed within the walls of an art institution, the work demonstrates how meaning is generated by context. After all, anywhere else it would simply be a malfunction in the electrical circuiting.

But not everyone could see the merit in Creed's prize-winning work. The press was outraged; one artist even threw eggs at it to register her disgust, which just goes to show that laying claim to a concept as a work of art still gets people riled. More than a decade later, Maria Eichhorn's *5 weeks, 25 days, 175 hours* (2016) similarly garnered much bafflement and bemusement. For her exhibition at the Chisenhale Gallery in London, the artist chose to close the gallery and give all the staff the duration of the show as paid leave to spend as they pleased. The gallery phones went unanswered and, except for one account on Wednesdays, emails went unchecked. Eichhorn explained in the magazine *Artforum*: 'The institution itself and the actual exhibition are not closed, but rather displaced into the public sphere and society.' The time given to the staff is where the work resides. Ultimately, the exhibition questions how we ascribe value to time in an age when work and leisure time are ever more intertwined and we rarely get the chance to pause and reflect. Whether we 'get it' as art or not, no doubt many of us would agree that it's not a bad idea. Even after half a century, there is something powerful in LeWitt's 1967 pronouncement: 'Ideas alone can be works of art.'

Felix Gonzalez-Torres, 'candy spills', 1990–93

BETWEEN 1990 AND 1993, the Cuban-born American artist Felix Gonzalez-Torres created nineteen untitled works that have come to be known as 'candy spills'. Each one is comprised of hundreds of sweets either piled in the corner of the room or carpeting a defined section of the gallery floor. Although not explicitly invited to do so, visitors may help themselves to the sweets if they wish. In some cases, the exhibition venue might choose to replenish the diminishing pile so that the form persists and, as sweets are removed and replaced, the 'candy spills' become a form of interactive sculpture held in a permanent state of flux. As Gonzalez-Torres explained, these works are a 'refusal to make a static form, a monolithic sculpture, in favour of a disappearing, changing, unstable and fragile form'.

But these works are about more than just refusing the formal constraints of sculpture: they are meditations on life and loss. *"Untitled" (Placebo)* (1991) and *"Untitled" (Placebo-Landscape-for Roni)* (1993) link the sweets to medicinal placebos used in drugs trials organized in the development of cures for AIDS, while in *"Untitled" (Welcome Back Heroes)* (1991) the use of Bazooka bubble-gum is a response to the devastating effects of the Gulf War (1990–1).

One of the best-known works in the series, *"Untitled" (Portrait of Ross in L.A.)* (1991), made up of 175 pounds (approximately 80 kilograms) of multicoloured wrapped hard sweets heaped in the corner of the room, is an ode to the artist's partner, Ross Laycock, who died of an AIDS-related illness in 1991. The weight of the work is commonly understood to represent the approximate weight of a healthy person. Each piece of candy that visitors take away could therefore be interpreted as a reminder and acknowledgment of Laycock's weight loss prior to his death. Whether knowingly or not, visitors act collectively to mark Laycock's suffering and preserve his memory, and this shared experience through art can offer a deep sense of connectedness. The work is a poignant and very personal memorial, but also a conceptual testament to life's constant shifts.

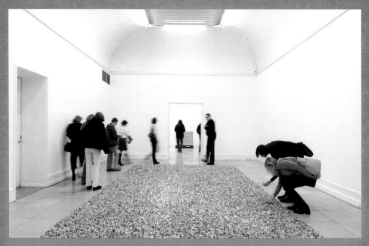

Felix Gonzalez-Torres, *"Untitled" (Placebo-Landscape-for Roni)*, 1993

Installation view of 'Goldrausch: Gegenwartskunst aus, mit oder über Gold' (Gold Rush: Contemporary Art Made From, With or About Gold), Kunsthalle Nürnberg, Germany, 18 October 2012–13 January 2013

Joining the Dots
What do curators do?

BEHIND EVERY EXHIBITION, the guiding hand of the curator is always present, setting out the rules of engagement between you and what you experience. Today we talk of curating everything, from playlists to wine collections, but the idea of a 'curator' or 'curatorship' originally emerged in the seventeenth century to describe someone who takes care of a museum or library collection. Over the last fifty years, curators have outgrown their traditional roles and absorbed a whole variety of new ones to fit today's expanded art world. Nowadays, curators come in all sorts of guises – they might be independent or museum-affiliated, groundbreaking or historicizing, local or global – but they continue to be the force that connects the artist, art and the public.

In a museum of contemporary art today, the curatorial department is typically divided into sub-departments. Although this varies from one museum to another, they are largely divided according to 'medium' (painting, sculpture, drawing, video), 'period' (twentieth-century, contemporary) and 'region' (Asia, Latin America). Each of these departments is made up of curatorial assistants, assistant curators, curators and, at the head of the team, a chief curator. Many museums also have one or more collection curators. Their work might involve proposing new artworks to be purchased for the museum's permanent collection (this is called an 'acquisition'), researching and writing on the works for the public ('interpretation'), as well as thinking of new ways to display the collection → see Q.

Across the board, the core process of organizing a temporary exhibition is essentially the same, whether it's at a large museum or a small independent art space. The curator proposes an exhibition concept and begins researching relevant works or artists. It is the curator's role to oversee everything, from selecting artworks, obtaining loan agreements and deciding on the hang, wall colour and texts, to exhibition catalogues, transportation and insurance. At a museum, it sometimes takes the curatorial team as long as three or four years to see an exhibition open. During this period, the curator is often

as much a fundraiser, budget-master, interpreter and negotiator as an exhibition manager.

Curators oversee every aspect of an exhibition, from selecting artworks and putting together exhibition catalogues, to choosing the wall colour.

Then there are those who work beyond the confines of institutions. Visionary thinkers adopting an experimental or multidisciplinary approach are invited to realize their ideas at biennials and triennials. These curators are often questioners and anarchists, who seek to challenge existing exhibition formats. Successful ones may even earn the nickname 'super-curator' and they regularly top lists of the most powerful people in the art world → see L. There is also a posse of globetrotting independent curators, who would not hesitate to describe themselves as curator-critic-writer-artist-academic-dealer. As the art world expands its borders and takes on new interests, each curator is encouraged, even compelled, to develop the role in his or her own way. While an aspiring student might follow the traditional course of an art history degree or enrol in a curating programme, paths to becoming a curator are varied and the role of a curator is ever-evolving.

The exhibition schedule, from idea to install

How does an exhibition happen?
What do curators do when it comes down to it?

One day...
you have a brilliant
idea for an exhibition.

Check if it's been done before.
Don't forget to run it by
someone (boss/peers/your mum).

Think of artists and artworks that
could be in the show. Ask yourself:
· Do they work together?
· What does each one bring
 to the show?

Draft a concept statement/exhibition
proposal. Clarifying your concept
is crucial for pitching the show to
potential artists, funders and press.

Do you have a space? ———————————————— YES ———

NO

Contact potential spaces. Think outside
the white cube. For instance, how many
works can you fit in your kitchen?

Send out loan requests/consignment agreements to whoever is lending the works. This could be public museums, private collectors, commercial galleries and even the artists themselves. If you are working directly with artists (performances, commissions), send out contracts.

Check the availability of works and revise the list. Time to face reality. Questions to ask:
· Are there any challenging installations?
· Are they charging a loan fee, and is it within the budget?
· Does it meet health and safety requirements?
· Can the work be transported?

Now is the time to narrow down your list of works. You have your concept, but what exactly will be in the show? Who and what would your ideal show feature? Conduct artist's studio visits, contact galleries. Do your research.

Make your budget, and make it detailed. It will be your friend and enemy, so take time to get to know each other.

YES

Create an exhibition schedule. This should establish a timeline for each task right up to the opening date. Pat yourself on the back for using Excel. Probably a good idea to get an intern at this point.

Do you have money?

NO

Get that exhibition proposal out there. Trawl the Internet for grants and sponsors. Network. You need that money!

Revise the exhibition concept as artists accept and loans are secured. Think about how you will fill the space and create a provisional layout.

Arrange transportation and insurance cover for the works. Are any coming from overseas? Can you afford the transport costs?

Are you going to have an exhibition catalogue?

YES →

Do you have time to write something?
Is that a good idea?

Commission writers and book designers. Deal with copyrights for images.

NO

Write wall labels, texts and exhibition guides. Sort out graphics, typesetting and wall colour.

Finalize that floor plan and book the technicians. How the hell will you deal with that random pillar in the middle of the room?

Figure out marketing. Write your press release.
· Who is your audience?
· Which online and offline platforms will you use?

?!

Send out invitations to the opening. Book travel and accommodation for artists.
Oh, budget. Maybe not.

GO HOME AND PASS OUT.
Another exhibition
 awaits tomorrow...

YAY! It's the opening night. Have a glass
of champagne (or tap water, depending
on the budget). Be prepared to have the
same conversation over and over and
over again.

Brief your gallery staff about
the exhibition.
· What is it about?
· Can people touch it?

DISASTER! Brace yourself.
There is always one.

Handle every little thing that
goes wrong. You are awesome
and totally on top of it!

Change your mind about
every aspect of the show.
 Piss everyone off.

Convince the artists not to change their
minds about every aspect of the show.
Try not to piss them off.

Make your FINAL floor plan for
the ten-millionth time. Begin install.
This is when the shit hits the fan.
· Does everyone know what they're doing?
· Are they doing what they're supposed
 to be doing?

Proofread the publication before
sending it off to the printers.
Thank God for the interns...

CANCEL ALL YOUR PLANS
FOR THE NEXT TWO WEEKS.
NEVER LEAVE YOUR PHONE
UNATTENDED. FORGET SLEEP.

Knowing Your Audience
Can art really be for everyone?

WE ALL KNOW THE FEELING: you step into a gallery and suddenly you feel like you have to be on your best behaviour, stand a little straighter, use obscure vocabulary and try your hardest not to say anything stupid. It's uncomfortable and it's oppressive, and a lot of people feel this way → see W. But, believe it or not, this is something that many museums are working hard to change.

When it comes down to it, one of the first responsibilities of cultural institutions is to promote an understanding of art. Many museums have an 'education' or 'learning and participation' department specially dedicated to making sure the art exhibited is relevant and accessible to as many potential visitors as possible – children, adults, art professionals, international tourists and local communities. One way to engage these different audiences is by engineering an events programme with strands tailored towards each one. This may include gallery tours for visitors with disabilities, school workshops, activities for families, academic symposia, lectures and talks. Museums also engage with online communities who may never visit in person through online magazines and blogs with comments boards, live-streamed lectures and performances, and Twitter sessions with artists and curators.

Alongside this flurry of activities, considerable resources are also put towards identifying new audiences. This stems from a fundamental understanding that the audience is not an abstract figure, but a variety of different kinds of people with diverse interests. Research and outreach are therefore crucial to understanding why certain sectors of the public, be it young people or local residents, find an art museum alienating. Some institutions seek to address this by inviting select visitors to become advisors – conduits between communities and the museum – and help create relevant programmes that will engage their peers. The result is diverse, personalized and more dynamic content, co-produced with visitors.

This endeavour has become all the more urgent as visitors seek a more active engagement with art – they don't want to be

treated like passive consumers. In an era when people are accustomed to exchanging views and participating through social media and digital platforms, creative activities and social interaction are fast becoming integral to cultural engagement. More interactivity – in essence, more conversations and fewer lectures – can allow for multiple readings, with many different voices contributing to a deeper and more personal engagement with the art. At museums, educators more and more often adopt an 'interpretive' approach (asking questions!) where learning, understanding and appreciating art starts with what people already know and builds further meaning from there. By encouraging visitors to really look closely at an artwork and inviting their personal responses, museum staff hope to facilitate an exchange that re-invigorates the work with new meanings.

In an era when people are accustomed to exchanging views and participating through social media and digital platforms, creative activities and social interaction are fast becoming integral to cultural engagement.

After all, what role can contemporary art play if its audience is only a small minority of the population? And who really is entitled to speak for art → see H? If the art experience is a personal one, then perhaps the best starting point is to encourage one-on-one engagement and share that with others. And if a museum seeks to inspire, then perhaps it can best achieve this goal as an agent of creativity rather than as a storehouse of objects → see Q.

Fun!

GIANT SLIDES, an inflatable Stonehenge bouncy castle, a room filled to the ceiling with balloons: contemporary art can be fun and we know you love it! Being invited to leap around on an art object can be exhilarating and empowering, especially in a space that can feel constricting and austere. In courting audiences, both artists and museums are trying to tap into what it is that makes people feel alive, and this has placed fun higher up the agenda. After all, fun can be tremendously powerful as a break from ordinary social conduct (screaming at the top of your lungs and actually talking to strangers), encouraging playfulness (rediscovering a side to yourself that your husband of ten years doesn't even know), and creating a sense of wonder and being in the moment (forgetting life's worries) → see A.

But the more people flock to these works, queue for hours to see them and take fantastic pictures for their Facebook profiles, the more such works are condemned as crowd-pleasing, child-friendly or pandering to a spectacle-hungry press. The concern is that such emphasis on exciting audiences and generating visitor figures is damaging to culture by creating a vogue for art that is immediately accessible but lacking in depth – the art equivalent of fast food. Critics contend the immediacy of this kind of art (the 'wow' factor) does not require visitors or artists to give it much thought.

Whether you view such works as art for all the senses or little more than an overblown playground, there is something to be said for firing up people's imaginations and getting them through the door. Visitors might have an entertaining Sunday afternoon or they might have a truly inspiring experience. Either way, a fun work of art might be just the push they need to open them up to all that contemporary art has to offer. And can there be a better way to convince your six-year-old that museums aren't all boring?!

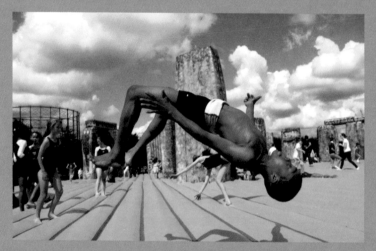

Children enjoying Jeremy Deller's *Sacrilege*, 2012, a co-commission between
Glasgow International Festival of Visual Art and the Mayor of London.
With support from Arts Council England, it travelled around the UK

Lovers and Haters
Who decides what matters?

PEOPLE ALWAYS SAY once you're 'in', you're 'in' – but who decides who's 'in' and who's 'out'? The annual rankings of the art world's 'who's who' don't just exist to encourage industry gossip. They tell us who's pulling the strings and the same names crop up time after time. It's thanks to them that you suddenly recognize that artist's name, when you wouldn't have had the faintest idea who he or she was a year ago.

Let's start with the super-curators. These are curators, independent or affiliated to an institution, whose intellectual interests and selections of artists are tremendously influential → see J. To be included in an exhibition curated by the likes of Hans Ulrich Obrist (Director of Exhibitions at the Serpentine Gallery, London, or 'HUO' to those in the business) is a nod of approval and pretty much guarantees instant global visibility. And just why are these particular curators so super? Because they curate shows that are almost always worth looking at – shows that make us re-think the experience of an art exhibition and spotlight artists whose practices push the boundaries of what art can be. For artists, the validation and visibility that comes with inclusion in an exhibition of this kind can be career-changing. It can lead to other exhibition and press opportunities, a rise in prices, and hot pursuit from galleries and collectors.

Next up are major collectors. They make it their business to visit these super-curators' hottest new shows, as they traverse the globe to stay up to speed with the art world's rising stars and all the latest talking points. While some collectors choose to keep a low profile, many of them are as famous as the artists they collect and the collections they build. Sometimes they even build private museums to showcase their collections: take David Walsh's Museum of Old and New Art in Tasmania, Australia, or Bernardo Paz's Inhotim in Brazil, for instance. Though they may be guided by advisors, the art in their collections is considered a manifestation of their own distinct taste. Collectors can afford to be much more playful with their spending than public museums as they are not bogged down by strict acquisitions policies → see Q. A few

collectors have become almost synonymous with certain artists, propelling their prices and reputations to new heights – think Charles Saatchi and the Young British Artists – or new lows should they decide to sell! Indeed, who and what these collectors buy and sell can have a major impact on the market.

These days, an artist can become flavour of the month overnight. Sales, good reviews and fame all happen so quickly that we often forget the role good old art criticism can play in offering more studied judgment. Drawing on art-historical and industry knowledge, critics are able to justify and contextualize their arguments. These experts range from art historians and journalists to bloggers, and although it may hold true that all publicity is good publicity, there are still a few big names whose opinions carry more weight than others.

It's thanks to these tastemakers that you suddenly recognize that artist's name, when you wouldn't have had the faintest idea who he or she was a year ago.

Also in the mix are art prizes and the panels of arts professionals who judge them. A prize can do an awful lot for an artist's prestige, generating publicity and notoriety. Equally, we cannot discount the role of galleries who are always pushing the artists on their roster → see N.

Taste-making in the art world is a complex phenomenon and it's near impossible to measure the role of individual movers and shakers in any particular rise or fall. But you can rest assured that the art that comes to your attention has been marked out by people of all stripes who really know their stuff. Maybe worth a second look then...

Turner Prize

EVERY YEAR, countless prizes are awarded all over the world to contemporary artists in recognition of their contributions to the field. Some are organized by public institutions, some by private foundations, and many of them have specific criteria for inclusion, such as age, nationality or stage in career. The selection of curators, critics, artists and gallerists invited to sit on the judging panels can really show who holds influence, institutionally and internationally. For the artist, the nod of approval from these tastemakers opens up possibilities for greater visibility – a nomination alone can be career-changing.

The Turner Prize is perhaps the most notorious of them all. Since it was founded in 1984, it has become one of the most talked about events in the art world and a source of entertainment for British media. The prize, which is organized by the Tate Gallery in London and named after J. M. W. Turner, the famous English painter of the industrial age, is presented to a British artist under fifty for an outstanding contribution to British art. The winner receives a £25,000 cash prize, but all four shortlisted artists are invited to take part in an exhibition of nominees. The location of the exhibition alternates every year between Tate Britain and a venue outside London, in an effort to bring contemporary art to people all over Britain.

The Turner Prize shortlist is generally thought to reflect the state of contemporary British art and it is considered a strong indicator of who might be the future stars. In fact, most of the artists nominated become known to the general public for the first time as a consequence. The much-adored Grayson Perry was certainly no household name before his 2003 win. But most of the nominees who shoot to fame through the prize do so because of the widespread uproar provoked by the work they display. Who can forget how Chris Ofili won in 1998 for a series of glittering glow-in-the-dark paintings incorporating elephant dung? No matter that many of them took up issues of race and identity...And where would Tracey Emin be today without all that fuss about her unmade bed? She didn't even win that year!

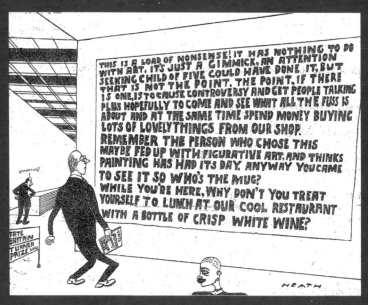

Michael Heath's cartoon for the *Mail on Sunday*,
3 November 2002

Money, Money, Money!
Why is it so expensive?

Now AND AGAIN, the price of an artwork causes outrage and elicits the most vehement of criticism. Why the world's wealthiest would choose to pay far more for a painting or a dead shark than most would pay for a house has been the subject of much bafflement and controversy.

In the contemporary art market, pricing is largely determined by middlemen – those acting between the producer (artist) and consumer (collector). Primary market sales, that is, new art entering the market for the first time, occur principally through galleries that 'represent' selected artists and manage their sales → see N. Usually named after the gallery owner, the bigger commercial galleries may be hard to distinguish from public galleries from the outside. It is in the back offices and private viewing rooms of these commercial spaces that prices are set and negotiated.

While there are no predetermined guidelines for pricing in the primary market, there are factors that can certainly sway things. For instance, a print of which there are several identical copies will be priced lower than a unique painting by the same artist, and bigger sculptures tend to sell for more than smaller ones. Production and material costs often have less to do with the pricing than you might expect. In fact, other less easily quantifiable factors tend to play a bigger role: the artist's 'brand value', whether other works by the artist are in well-known private or public collections and whether the artist has had major solo exhibitions in important museums. The name value of the gallery itself can also carry some weight. For emerging artists, being picked up by a major international gallery can catapult the price of their work.

But drastic leaps in prices are not always a good thing. Galleries are always cautious of collectors buying with the intention of 'flipping'. This is when a work is bought and then sold on right away at a significantly higher price to make a quick profit. When this happens in the secondary market – the market for the sale of art that has been sold at least once before – the sudden leap in price makes the artist vulnerable to an equally sudden price drop. It can

destabilize the market for his or her work and have a serious impact on the artist's career in the long run, especially if he or she falls visibly out of favour. Indeed, the role of the gallery is to implement a pricing structure that rises steadily in line with the artist's stature, protecting them from speculation and creating a secure notion of value. Galleries carefully vet collectors and only sell work to those they trust not to flip it. This involves trying to establish that potential buyers are committed to building a collection, so a gallery may ask what other galleries the collector buys from and what other works they own.

> **Why the world's wealthiest would choose to pay far more for a painting or a dead shark than most would pay for a house has been the subject of much bafflement.**

The most spectacular arena for observing the sale of art in the secondary market is the auction house. Once a seller consigns a work to auction, specialists carefully set an estimated price that usually hovers between two figures, the high and low estimates. Usually a consignor (seller) will agree a secret minimum price for which the auction house may sell the work, called a 'reserve'. This means that, should bidding not reach the low estimate, the auctioneers know the minimum bid they can accept. The ridiculously high prices that are reported at high-profile auctions sometimes take into account the 'buyer's premium' – the surcharge added by the auction house, usually between ten and twenty per cent of the hammer price, depending on the auction house and the price of the work being sold. On top of that, auction houses also slap on the 'seller's commission'. While extortionate sales figures might give the impression that auction houses are bathing in money, there is some risk and a lot of legwork involved. They will,

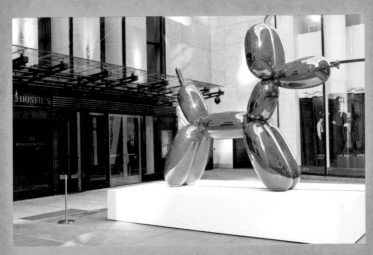

Jeff Koons, *Balloon Dog (Orange)*, 1994–2000, on display
outside Christie's New York, prior to its sale at auction
for $58,405,000 in 2013

for particularly important sales, promise to pay the consignor a 'guarantee' regardless of whether a work sells at auction – a risky strategy, especially in a bad economy. Each auction also has a dedicated client liaison team that spends years courting high-net-worth individuals to win their loyalty when it comes to selling, and encourages them to place bids in forthcoming auctions.

During a sale, it is not uncommon for gallery owners to bid on work by artists they themselves represent in order to encourage bidding and, more importantly, to maintain the market price. The Post-War & Contemporary Art sales at Christie's and Sotheby's, the two largest international auction houses, regularly set record-breaking prices for a handful of highly popular contemporary artists, including Jeff Koons and Gerhard Richter. As with the primary market, the artist's brand value, previous sales prices and past ownerships can set the opening bid high, and as long as the desire to own is there, there is no limit to what prices can reach.

But who is buying all this art anyway? The market relies on a tiny elite of art-world movers and shakers – museums and wealthy individuals. Museums have a responsibility to maintain public collections, and receive private donations, taxpayers' money and serious discounts to assist them in doing so. For mega-collectors, art offers prestige – something you cannot put a price on. And while all of the above goes some way to explaining how a price might be determined, at the end of the day, it simply comes down to what people are willing to pay. After all, an orange *Balloon Dog* by Jeff Koons: $58.4 million. The look on your wife's face: priceless.

The 'Business Artist'

In September 2008, the renowned British artist Damien Hirst auctioned off 223 new works directly through Sotheby's in London, bypassing the traditional route of the gallery. As it happened, the sale coincided with the historic collapse of the American financial services firm Lehman Brothers and the onset of the global economic crisis. While Lehman fell and global financial markets reeled, this sale broke all records, bringing in £111 million.

Hirst is clearly as much a businessman as he is an artist. Sales of his work aside, Other Criteria, his shop, comfortably brings in $12 million a year selling brand products, such as prints and T-shirts. But he is certainly not the first artist to build a business around his work. The Andy Warhol 'brand' extended into diverse enterprises, including publishing, music management and television. His studio, 'the Factory', operated a range of art product businesses that he famously envisioned as 'the step that comes after art'. Each new venture expanded Warhol's own media presence, which in turn ensured its popularity and success.

The Japanese artist Takashi Murakami is another leading example of the contemporary artist-entrepreneur. His company, Kaikai Kiki Co., Ltd, employs several hundred assistants to design and fabricate his fine art works, as well as various product lines. While his paintings and sculptures may require a millionaire's bank balance, Murakami has also reproduced many of his best-known works as collectables like 'snack toys' packaged with sweets to offer a taste of his art to everybody. His collaboration with the French luxury fashion house Louis Vuitton (2003–15) saw his instantly recognizable multicoloured monograms and smiley-faced cherry blossoms adorning the handbags of fashionistas from Italy to Thailand. The partnership even led to a fully operational Louis Vuitton store at the artist's solo exhibition at the Los Angeles Museum of Contemporary Art in 2008.

To use Warhol's own words, 'Business Artists' translate into their practice the belief that 'making money is art and working is art and good business is the best art'. For these artists, being an artist is a job and art is the most valuable currency of all.

'Keepall 45' Multicolour Black Monogram canvas handbag from the
Louis Vuitton Women's Ready-to-Wear Autumn / Winter Collection,
2003–4. Pattern designed by Takashi Murakami

Next Big Thing
What is the role of galleries?

THERE ARE HUNDREDS UPON HUNDREDS of galleries out there. If you've ever set foot in an art fair, you'll know what it's like to feel overwhelmed by the number of galleries vying for your attention – and they're only a select few! At the top end are the likes of Gagosian and Hauser & Wirth. These 'blue-chip' mega-galleries lie halfway between intimidating shopfronts and small museums. With several branches worldwide, they sell works for massive sums to similarly 'mega' collectors. At the other end of the spectrum are smaller young galleries trying to make a go of it with one or two staff members and a temporary space, representing artists fresh out of art school. Big or small, most follow roughly the same business model.

For the most part, contemporary galleries 'represent' living artists and work with them to build their careers. Representation in the art world works in much the same way as it does in the music industry: the gallery has exclusive rights to sell and promote the artist's work within a given region in return for a share in sales. This means that some artists are represented by more than one gallery (one in Asia and one in Europe, for instance). Galleries will put together a rotating exhibitions programme, meaning that their artists take it in turns to exhibit new work. Most galleries will hold six to eight exhibitions per year, opening a new show at least every two months.

The quality of these exhibitions and the standard of the art on view are integral to establishing a gallery's reputation. A gallery is only as good as its artists, and a good reputation will draw more dedicated collectors and established artists into the fold. Nonetheless, galleries are businesses and most will be on the lookout for art they can sell. Often this means ensuring a delicate balance of artists: a couple of cash cows whose works sell like hotcakes to bring in the money and a few museum darlings who don't sell much but get curators through the door.

In essence, the relationship between the gallery and the artist is founded upon certain expectations and a commitment from both sides. The artist makes work for the gallery to sell,

and the gallery exhibits, promotes and sells that work. Unlike museums, galleries do not receive public money, nor do they charge admission. They are entirely dependent on sales for their livelihoods. In general, galleries take fifty per cent of the profits from any sale, i.e. after any discounts and taxes are taken off the top, and costs of production are returned to the artist.

> At their best, relationships between galleries and artists are founded on mutual admiration more than monetary interest.

Half the sale value may seem like a raw deal for the artist, especially as they tend to cover their own studio costs as well as fronting the production of the work. Can it really be worth it for them? The short answer is 'yes'. Galleries fork out masses in rent, offering exhibition spaces in prime locations and committing to regular solo showings of the artist's work. Each exhibition comes with all the trimmings, from opening events to press outreach and targeted sales development. Galleries spend a great deal of time cultivating close relationships with a network of collectors. Bear in mind that very few sales are to walk-in clients; they result from extensive email correspondence, with images and portfolios being sent back and forth, wining and dining – a lengthy process of getting to know the collector's likes and dislikes that inspires his or her trust in the gallery. After all, if you want people to part with thousands of pounds, they have to feel confident in what they are purchasing and those they are buying from.

Art fairs are prime opportunities for galleries to show new audiences what they have to offer. While everyone may complain about the dizzying and expansive nature of fairs, they are an incredibly convenient way for collectors and curators to see art from all over the world in a short space of time → see F. Most galleries will

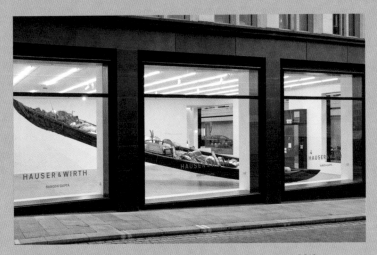

Subodh Gupta, *What does the vessel contain, that the river does not*, 2012.
Installation view at Hauser & Wirth, London, 2013

exhibit at several fairs a year, each one at considerable cost. A fair charges several thousand dollars for the hire of a booth, and there are the additional costs of shipping work to far-off countries, flights and accommodation for gallery staff, hiring technicians to install the work and build plinths, vitrines and the like...And don't forget the dinners and champagne receptions for key collectors!

In short, running a gallery is an extremely costly business, but that's what it takes to put an artist on the map. Artists could never afford to do all of this themselves and when would they have the time? Galleries are there to take these concerns out of their hands and assist with all of the other admin, such as managing their archives, fielding enquiries and securing press coverage, so that artists can focus on making the art. This in itself is invaluable, but often the most important support comes in the form of helpful feedback and advice. At their best, relationships between galleries and artists are founded on mutual admiration more than monetary interest, and this rapport is what draws many in the industry to become gallerists. Indeed, good gallerists are knowledgeable art lovers, often investing all their money and more in the futures of artists they believe in. For the vast majority this is not a lucrative business as huge overheads make for small profits, especially in times of economic instability. Yet, in spite of ups and downs, new galleries continue to arrive on the scene, fuelling the art world with their enthusiasm as they present their fresh roster of artists. Who knows, one might just be the next big thing.

Art Basel

THERE'S ONE WEEK A YEAR that is guaranteed to feature in every gallery's calendar, and that's Art Basel. Held in the Swiss city of Basel every June since 1970, it is, without compare, the most important art fair in the world.

For galleries, it all starts about nine months beforehand when applications open and they submit proposals detailing which artworks they wish to bring to the fair. It's a highly competitive process and, if accepted, many galleries save their best works to debut there. With more than 300 galleries exhibiting, the fair is divided into various sections to ease the chaos. These range from 'Galleries' (the big-name, high-sales, 'blue-chip' galleries) to 'Statements' (a curated hub of young galleries each presenting one artist's work) and 'Unlimited' (an exhibition of spectacular large-scale works). Galleries will make sure that they apply to the most appropriate section for the best chance of being accepted.

Although the fair organizers have built up a programme of carefully curated sections, panel discussions with artists and critics, and film showings around the fair to provide a more broadly enriching experience, there is no doubt that this is a commercial enterprise. Admission to the first three days of the fair is by invitation and strictly VIP only, and even this is further divided into tiers. The highest-profile collectors and curators are the first through the doors, with first dibs on the art on offer. A few hours later, the next tier is permitted access and so forth, with the general public only able to enjoy the fair a few days after it actually opens. For the galleries, these first few days or even hours are crucial, and sales teams are at the ready with their price lists and bottles of champagne when the doors open.

Today Art Basel is in fact three fairs, with additional iterations each year in Hong Kong in March and Miami Beach, USA, in December. As a brand, it has been tremendously successful, drawing visitors from all over the world, and Miami and Hong Kong have likewise become unmissable stops on the art fair circuit. Around the world with Art Basel? That's just one of the perks of the job.

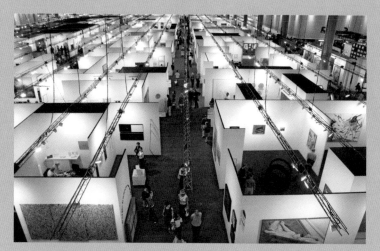

View of Art Basel Miami Beach at the Miami Beach Convention Center

Oh No You Didn't!
Is that really necessary?

ARTISTS HAVE LONG SHOCKED PEOPLE by flouting the conventions of their time: Manet's painting of a nude woman sitting with two clothed men caused an uproar in 1863, critics were scandalized by the Impressionists' hazy landscapes in the late nineteenth century, and let's not even start on Duchamp's urinal. In fact, this transgressive spirit, which was a distinguishing feature of Modern art, persists in the practice of many contemporary artists today, who marshal the power of shock to captivate and to elicit strong emotions. But why do it? Is it all just for the hype?

Projected onto the floor of the gallery in a small cubicle, Mona Hatoum's *Corps étranger* (1994) - the title translates as 'foreign body' - features footage shot by a tiny medical camera as it explores the contours of the artist's body. Then, almost brutally, it probes inside, down her throat and up through her vagina and anus. It's both fascinating and unnerving to watch. On the one hand, this journey through her guts is clinical and uncomfortable; on the other, it's incredibly personal and intimate. Hatoum is showing you more of herself than you've probably ever seen of anyone. In the artist's words, it's a self-portrait that forces us to confront 'the facts of our physicality' - blood, guts, all of it - and she uses this 'physical experience to activate a psychological and emotional response'. It's this queasy discomfort that allows the work to pack a punch as a commentary on the fascination, disgust and violation variously associated with women's bodies, but also as the ultimate invasion of privacy in a society obsessed with surveillance.

While you might be forgiven for questioning whether Hatoum really needed to insert a camera into her vagina and take us on a tour of her insides, the fact remains: shock hits you in your gut. And that's important: artists can use that. In the case of *Corps étranger*, it is this immediate visceral response that sticks in the mind and forces us to pay attention. On the other hand, Maurizio Cattelan's *Him* (2001) provokes a different kind of shock. Approached from behind, the work appears to be a very lifelike sculpture of a child kneeling in prayer, but seen from the

O

front the kneeling figure is in fact an exact, albeit miniature, waxwork replica of Adolf Hitler. The work employs the shock of history – a history that remains raw for many. For some the sculpture is a meditation on the nature of evil and perhaps even a plea for humanity, while others have described it as a needless provocation and insult to Holocaust victims. At the very least, the work shows just how politically loaded Hitler's image continues to be and maybe it goes some way to eroding the power it holds over us.

Is all art that shocks us really so radical? As an approach, shock can jolt us into thinking differently, into recognizing our biases; it can take us outside our comfort zones and show us where the limits of acceptability lie.

But does it cross a line that needed to be crossed? Indeed, the question bears asking: is all art that shocks us really so radical? As an approach, it can jolt us into thinking differently, into recognizing our biases; it can take us outside our comfort zones and show us where the limits of acceptability lie. By testing those boundaries, artists prompt us to think about the ways our culture operates and provoke new understandings. But can we really learn something from Hitler praying? Are the Chapman Brothers' mannequins of children with genitalia for faces really necessary? And what are we to make of the artist Stelarc growing a prosthetic ear on his arm? Well, that's up to you. Shock presents you with the chance to work through such questions. And once the initial jolt has worn off, it's the next feeling that's really worth your attention.

Santiago Sierra

Over the past two decades Spanish artist Santiago Sierra has become known for works that employ people from the most marginalized sections of society – prostitutes, drug addicts, illegal immigrants, the homeless and unemployed – to enact tasks that are meaningless and often degrading.

For *250 CM LINE TATTOOED ON THE BACKS OF 6 PAID PEOPLE, Espacio Aglutinador. Havana, December 1999* (1999), the artist paid six unemployed men $30 each to have a line permanently tattooed on their backs. A year later, he paid four prostitutes with drug addictions the price of a shot of heroin for the same privilege. By paying unemployed men for their bodies and funding heroin use, Sierra positions himself in a way that many would consider unethical. In presenting these works as art, staging them at museums, and offering them for sale, he implicates the art world as well. And sometimes with unexpected results: Sierra recounted that when he paid a museum guard to live behind a wall at MoMA P.S.1 in New York for 360 hours in 2000, the guard later told him that 'no one had ever been so interested in him and that he had never met so many people' → see H.

In other works, Sierra has paid people to hold up heavy weights for as long as they physically can, hide in a wooden box being used as a bench at an art party, block a museum entrance and clean people's shoes without their permission. His choice of performers is unsettling given that, due to their socio-economic circumstances, they often have little choice but to accept the job. Exploitation is turned into a form of spectacle. In so doing, the artist draws attention to the fact that these exploitative relationships exist regardless of his intervention and that such power dynamics, and the questionable ethics that come with them, are almost inevitable under the conditions of capitalism. We are all complicit and this is no different – it's just less easy to ignore.

Santiago Sierra, *250 CM LINE TATTOOED ON THE BACKS OF 6 PAID PEOPLE, Espacio Aglutinador. Havana, December 1999*, 1999

Picasso Baby
Why does everyone
want in on art?

On 10 July 2013, rapper and hip-hop mogul Jay Z staged a private gig for a group of invite-only guests at New York's Pace Gallery in Chelsea. This was the debut of his new song 'Picasso Baby' and, to launch it into the world, he arranged a special six-hour performance of the track. The event was inspired by the performance artist Marina Abramović's show at New York's Museum of Modern Art three years earlier → see S. For *The Artist is Present*, she sat silently opposite gallery visitors one-on-one, every day for the entire duration of the exhibition – over 700 hours in total. In homage to Abramović's search for intimacy, her attempt to connect with each visitor in a wordless exchange, Jay Z directed his performance to individual guests in turn – a mixture of television stars, fans and art world royalty (including Abramović herself).

In the lyrics to 'Picasso Baby', art is not a space of creative freedom, but a luxury good to be owned and name-dropped. The song is a roll call of the biggest names in the art world – Picasso, Rothko and Warhol, Art Basel and Christie's. But essentially, what Jay Z wants you to know is that he's today's answer to Pablo Picasso, baby. Here, visual art is a symbol of wealth, a material extension of the self; its revered status allows Jay Z to shake off the shackles of pop culture and elevate himself to the rank of the greats, his rap to that of a magnum opus.

The allure of the art world has increased over the past few years, most noticeably for those in pop culture. Actors and musicians seek to step into the art world, and not just through collaborations – these performers want to be taken seriously as 'artists' in their own right. The recording of 'Picasso Baby' by Jay Z is not a music video; it is a 'Performance Art Film'. James Franco, the actor-artist-filmmaker-author, is now a regular on the gallery circuit. His paintings, photography, videos and installations have been presented in major solo exhibitions. Lady Gaga, global superstar and world-famous musician, launched a whole album titled 'ARTPOP', featuring Jeff Koons's artwork on the cover, and staged an album tour called 'ArtRave'. As she sings in 'Applause' and has also tweeted: 'Pop culture was in art, now art's in pop

P

culture, in me!' In a world that draws a sharp distinction between 'high art' and pop culture, it's all about harnessing the art world's cachet.

Crossing over into the art world certainly has its perks. It offers a marketing tool par excellence, garnering headlines, provoking controversy and bamboozling people. Jay Z's performance went viral within minutes, as did actor Shia LaBoeuf's decision to wear a paper bag on his head to movie premieres and hold audiences during opening hours at Cohen Gallery in LA in another homage to Abramović.

Here, visual art is a symbol of wealth, a material extension of the self; its revered status allows Jay Z to shake off the shackles of pop culture and elevate himself to the rank of the greats, his rap to that of a magnum opus.

Unsurprisingly, these crossovers are met with mixed reactions in the art world. While there is something to be said for breaking down the distinctions between art forms, removing hierarchies of creativity and wearing down art's elitism, each industry operates according to different rules of taste and measures of quality. In a field predicated on artistic integrity and authenticity, this brand of art as pop spectacle or flight of fancy strikes a little close to the bone. The Midas touch of a global superstar might simply not cut it. As the art critic Jerry Saltz said to James Franco in an interview in 2016: 'The art world is an all-volunteer army, and we all come here naked. We all have similar needs. I have no choice – I have no other hope. But you? You have all these other outlets, and yet you're trying. And it's almost impossible without your fame becoming the content.'

Kanye West, a minimalist
in a rapper's body

Kanye West's love affair with art began long before Kim Kardashian came along. It was West who asked Takashi Murakami → see M to design the cover of his 2007 album 'Graduation' which featured a drawing of his alter-ego, the College Dropout bear, as a varsity-jacket-wearing space traveller. It was also West who contacted the painter George Condo to create the cover for 'My Beautiful Dark Twisted Fantasy', his 2010 album. The result was five paintings inspired by Macbeth, ballerinas and West himself.

Indeed, it seems West has made it his mission to bring art to his music. In 2010 he enlisted the help of the artist Vanessa Beecroft to film his thirty-minute music video 'Runaway'. He also decided to hold an impromptu preview of his album 'Yeezus' at midnight at the 2013 Design Miami/Basel fair.

At the opening event for his 2015 video 'All Day/I Feel Like That' at Los Angeles County Museum of Art, a nine-minute live performance film created by the Oscar-winning filmmaker and artist Steve McQueen, West said: 'I would trade all my Grammys – or, maybe, two Grammys – to be able to be in an art context.' For West, art is not just a fleeting flirtation, but something to strive for, something that comes at a price – two Grammys, even. After all, it was this very determination that allowed him to conquer the music industry despite being told repeatedly that he would never make it as a recording artist. And so whether or not West correctly used the term 'minimalist' when he described himself as 'a minimalist in a rapper's body' to the *New York Times* doesn't really matter. It's what being an artist represents – the innate qualities of genius. And it's clear that West has his sights set high. In a lecture he gave at Oxford University, he explains: 'My goal, if I was going to do art, fine art, would have been to become Picasso or greater.' Even Jesus won't do, as West implies with his sixth album, 'Yeezus' (elevating the 'Ye' from his name into his 'god name'). In July 2015, West picked up an honorary doctorate degree from the Art Institute of Chicago – his chosen path to modern-day master may be unorthodox, but he must be doing something right.

George Condo, *Power*, 2010, from the album cover
of Kanye West's 'My Beautiful Dark Twisted Fantasy'

Quality Control
What is the role of museums?

IF ONE OF THE KEY GOALS of a museum is to collect, preserve and exhibit the cultural achievements of our past, what does this mean for a museum of contemporary art? In practical terms, it has meant that these museums, by capturing the visual culture of the present moment, are effectively predicting what will be historically important for the future. That is to say, contemporary works that receive the museum stamp of approval are marked out as deserving of a place in our future's past and written into that history. That's why, for artists, gallerists and collectors alike, it is so crucial to get the artworks they create, represent and collect exhibited in museums or, even better, into museum collections.

This confidence in the museum's authority stems from a belief that public museums are custodians of our shared history; that the objects displayed and preserved reflect our stories, struggles and achievements, and have the public interest at heart. They can also be a national resource and way to build a sense of local pride and shared patrimony. Since these official institutions are often in receipt of public funds, they must be able to demonstrate their fulfilment of this social responsibility and are held accountable to their board members and public authorities. Museums must therefore be able to justify their collections in principle, and stand for ideals that go beyond the mere personal tastes of their curators or trustees. For each museum, these overarching goals are often set out in a mission statement. Think of a museum's 'mission' as its 'unique selling point'. These can range from building a local arts scene and providing a platform for local artists, to something more specific, such as bringing together the disciplines of art and technology as in the case of FACT (Foundation for Art and Creative Technology) in Liverpool, UK.

In practice, the museum mission is carried out through its exhibitions and public programmes → see K, as well as by building collections and preserving objects. As the primary attraction for visitors and the main focal point for the press, exhibitions are the public face of a museum. These are important as they allow a glimpse into the particular artists, art forms, movements or

Q

history that the museum deems significant. For artists, the inclusion of their works in these temporary exhibitions (usually on display for two or three months at a time), especially if it's a solo show, can be life-changing, as this is seen as validating their practice. Still, it is easy to forget that exhibitions are just one manifestation of a museum's larger mission, with its activities stretching across a wide variety of public and research programming. For instance, SALT, a not-for-profit institution in Istanbul, was first opened in 2011 to develop a cultural community within Istanbul and foster the writing of a Turkish history of art.

Contemporary works that receive the museum stamp of approval are marked out as deserving of a place in our future's past and are written into that history.

While some museums are exhibition halls only (often referred to using the German term 'Kunsthalle', which loosely translates as 'art gallery') and bring together a range of temporary exhibitions, many have their own collections on permanent view. It is often only possible for a fraction of these collections to be on show at any time due to a lack of exhibition space – these works are collected to fulfil the driving goal of preserving them for future generations, not to fill floor space. Each collection will have its own 'collection strategy' (a specific focus) and 'acquisitions policy' (process by which new works are approved) that are aligned with the museum's overall mission and identity. The strategy of Tate Modern in London, for example, has been to focus on the 'international' to distinguish it from Tate Britain, also in London, which is dedicated to building a preeminent collection of British art.

Collecting for posterity implies that these works must be held indefinitely, i.e. forever. Naturally, the problem with collecting

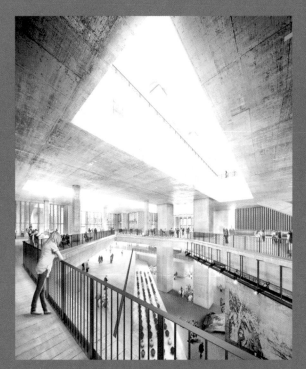

Architectural rendering of Found Space inside M+, a museum
designed by Herzog & de Meuron to be built in West Kowloon
Cultural District, Hong Kong

contemporary art is that, at best, it is an educated guess which artworks will stand the test of time. It is anticipated that works added to the collection will retain their significance and grow in value, but this may not be the case. And don't be fooled by the phrase 'permanent collection': collections and collection-building are fine-tuned and regularly undergo a review process. As years pass, museum management changes and certain artists may fall out of vogue. Or a museum may find itself in hard times, in which case the idea of raising money through the sale of a work from the collection may gain traction. The removal of an object from the collection through sale is known as 'deaccessioning'. If this does happen, many museums have strict rules in place – the most important of which is that the proceeds from the sale of the deaccession can only be used to buy other works of art. Needless to say, building a collection is a complex and major financial and ideological undertaking, rife with difficult decisions. For many in the art world 'deaccessioning' is a dirty word as they contend it privileges short-term gain. After all, the driving aim of a collection is to preserve a legacy.

In essence, each museum seeks to ensure that the best new work is supported and that nothing of note falls through the cracks. So if you are tempted to forgo the art museum on a rainy day, remember: museums of contemporary art are more than fancy buildings with overpriced cafés, they are among the most powerful forces in the art world.

Museum acquisitions

A NEW WORK that enters a museum collection is typically called an 'acquisition' and while there are several ways this can happen, the two most common are by purchase or as a gift. Purchases are made through special acquisition committees that may focus on different price points, media (photography or film, for instance) or regions (such as the Middle East or Asia-Pacific). Museums will have several committees, each consisting of members who provide the funds to acquire works (the folk acknowledged in the last line of museum labels).

Overall, the acquisition process tends to follow the same format: curators identify works they think have gained, or will gain, historical significance and contribute to the museum's existing collection and mission. Since each committee has a different collecting agenda, the rationale will differ each time. Once the curators get the green light from the director, they present the work to the appropriate committee, explaining the reasons why the proposed piece is desirable for the museum. Following the committee's stamp of approval and an 'okay' from the conservation team, who ensure that the work is in mint condition, it is finally presented to the museum's board for ratification. Seeking the board's approval is mandatory whenever a work enters the collection. Even gifts offered by artists or donors must be approved in this way. Once ratified, the work is 'accessioned' with a unique collection record and becomes an official holding of the museum.

Making an acquisition is a long process that requires a great deal of effort and consideration, not only from curators, but from all museum staff involved. Conservators interview living artists to help the museum plan future preservation → see T; registrars take care of the logistics, such as transport and storage; lawyers handle all the complex legal aspects; and the development team keeps everything afloat by cultivating relationships with donors all year round. Such commitment shows how integral the acquisition process is to what museums do and the lengths museums go to in order to ensure that the very best artworks enter their collections.

Society of Contemporary Art Annual Meeting and Acquisition Vote
at The Art Institute, Chicago, 14 May 2014

Rattling the Cage
Can art build a better world?

In 2015, the Chinese artist Ai Weiwei announced his plans to construct a new studio on the Greek island of Lesbos, a site that has drawn hundreds of thousands of migrants amid the ongoing global refugee crisis. The studio looks to focus on projects that draw attention to the plight of refugees. Ai explained, 'As an artist, I have to relate to humanity's struggles...I never separate these situations from my art.'

Indeed, Ai's practice has long taken up social causes. For instance, the installation *Remembering*, created for the Haus der Kunst, Munich, in 2009, was made from 9,000 backpacks to symbolize the 9,000 children who died when shoddily constructed 'tofu skin' schools collapsed during the 2008 earthquake in Sichuan, China. Alongside his practice, Ai has also harnessed the power of social media to bring visibility to his causes. His criticism of the arbitrary exercise of power by Chinese officials even led to his arrest in 2011, when he was detained for three months by the Chinese government on dubious charges of tax evasion.

As Ai's run-ins with the authorities attest, art has the power to challenge, question and critique. It can give visibility to the socially marginalized, raise ecological concerns, and attack systems of political and economic power. And not even the art world is exempt from becoming the object of attack. Such 'institutional critique' focuses on the forces, both visible and invisible, that control art's production, representation, consumption and distribution → see H. In the video *Is the Museum a Battlefield?*, shown first at the Istanbul Biennial in 2014, Berlin-based filmmaker and writer Hito Steyerl gives a performance lecture tracing the origins of an empty bullet casing that killed her friend, a PKK (Kurdish Workers' Party) fighter. In the fantastical thirty or so minutes that follow, Steyerl weaves a complex story about the interconnectedness of war and art museums, playing on the fact that the arms used by the Turkish authorities are manufactured by subsidiary companies of one of the Biennial's sponsors. The timing of the work was especially poignant given that the Biennial opened after months of protests and civil unrest in Istanbul.

R

While Steyerl reminds us how the art world is often fuelled by dirty money, others, such as The Yes Men, aim to set the rest of the world to rights. Not particularly interested in calling themselves 'artists', this dynamic duo aims to address the wider public rather than just the museum-going crowd. Assisted by a network of supporters, Jacques Servin (whose aliases include Andy Bichlbaum) and Igor Vamos (aka Mike Bonanno) use parody and humour to bring worldwide media attention to what they describe as the very 'mechanisms that keep bad people and ideas in power' and 'the dangers of economic policies that place the rights of capital before the needs of people and the environment'. They make films and have also posed as spokespersons for the fuel company Exxon, Dow Chemical (the company linked with the chemical disaster in Bhopal, India), and the World Trade Organization, appearing on television and at conferences to make ridiculous comments that caricature the capitalist ideologies of such organizations.

Art has the power to challenge, question and critique. It can give visibility to the socially marginalized, raise ecological concerns, and attack systems of political and economic power.

Of course, there's a risk that such one-off interventions pass unnoticed by the general public and have little social and political impact. But to judge a work by its results may be to miss the point. These artists use the tools they have at their disposal for their own form of activism – and often it goes beyond politics, condensing complex histories into powerful and poetic works that strike at the core of our humanity → see A. Just as little strokes fell great oaks, so these artists act in the belief that doing something is much better than just sitting around complaining.

Tania Bruguera

In 2014, the detention of Cuban artist Tania Bruguera made international news headlines. The Cuban government had arrested her and prevented her performance piece *Tatlin's Whisper* from being enacted in Havana's Plaza de la Revolución. The work in question, originally presented at the tenth Havana Biennial in 2009, invited visitors to climb an empty podium and address the public uncensored for one minute, after which time they were escorted away by two men in military uniforms. A white dove was placed on each speaker's shoulder – an allusion to the one that landed on Fidel Castro during his first speech in Havana after the triumph of the 1959 revolution. For the speakers, art proffered a temporary platform for free speech in a climate of extreme censorship. Some were calm, others shouted and several cried. According to the artist, the re-staging of this work in 2014 aimed to enable Cubans to 'peacefully express what ideas they have about their nation and its future, after the re-establishment of relations between Cuba and the United States'. Released from the confines of its original art context into the public arena, it became a threat that had to be suppressed.

Bruguera has long explored the relationship between art, activism and social change. In her practice she pursues what she calls *arte útil* ('useful art') through long-term projects that address sociopolitical issues. In 2011, for instance, she started an ongoing project called 'Immigrant Movement International' in Corona, Queens, an immigrant-rich neighbourhood in New York. Organized in conjunction with the Queens Museum and Creative Time, a not-for-profit arts group, it involved the creation of an open community space that helped immigrants and raised awareness of their struggles by providing English classes, legal advice and some healthcare, in addition to art workshops. Since 2016, Bruguera has been able to expand her work with undocumented immigrants through her appointment as the first ever artist-in-residence for the Mayor's Office of Immigrant Affairs in New York City. Across her practice, Bruguera demonstrates her belief that art really can be a 'useful tool to materialize a vision of a more inclusive society'.

Tania Bruguera, *Tatlin's Whisper #6 (Havana version)*, 2009

Stage Presence
What is performance art?

THE POWER OF PERFORMANCE ART lies in its immediacy. As RoseLee Goldberg, founder of New York's performance art festival Performa said: 'What better way to make people pay attention than to say "Look at me, I'm standing in front of you"?' And because the body takes centre stage as the medium, performance art has proved a useful tool for exploring how we relate to ourselves and others, as well as issues of gender and race.

Between 1968 and 1971, Joan Jonas used mirrors in a series of performances to examine the objectification of the female body and women's fixation with self-image. In one performance, she stood naked before an audience inspecting her own body with a small round mirror, as if she were encountering herself for the very first time. This moving work brought to the fore the potency of another's gaze: it demonstrated the powerful position of the viewer, who could see the artist in one steady, unbroken view as opposed to the fragments accessible to Jonas herself. It is this physicality, this heightened consciousness of the artist's body and, by extension, our own bodies, that often comes through most strongly in performance art.

The Taiwan-born artist Tehching Hsieh is best known for his five *One Year Performances*. Between 1978 and 1986, the artist spent one year locked inside a cage, one year punching a timeclock every single hour, one year completely outdoors, one year tied to another person and, lastly, one year without making, viewing, discussing, reading about, or in any other way participating in art. The 365-day length of the works was paramount, as it intensified the piece from a single performance into real life, with the experience of living becoming his art and vice versa. Through these feats of endurance, Hsieh prompted us to reflect on the circumstances of our being and existence, in other words, what it means to live.

Performance art's immediacy and its power to closely reflect our personal experiences has encouraged artists to use it to step into the lives of different communities. For *When Faith Moves Mountains* (2002), artist Francis Alÿs assembled five hundred

volunteers in single file at a sand dune on the outskirts of Lima, Peru, and together they shovelled it forward by a tiny distance over the course of a day. This futile action, which expended enormous amounts of energy and time, questioned the notion of progress as Peru painfully transitioned from dictatorship to democracy. Other works are premised upon a more direct exchange with the audience. In Roman Ondak's *Swap* (2011), a performer sits at a table in an exhibition space with an object and tries to swap it with anything the visitor might be carrying. This sets in motion a chain of bartering that questions people's relationships to their possessions and prompts us to think about value and exchange.

It is this physicality, this heightened consciousness of the artist's body and, by extension, our own bodies, that comes through most strongly in performance art.

As this handful of examples shows, performance art is a varied field and each new work of art has the potential to expand the scope of its definition. It refuses to be trapped in one guise or methodology – after all, there isn't just one way of creating performance art – and that is why it produces some of the most challenging and impactful works out there.

Marina Abramović

Marina Abramović is the undisputed queen of performance art. With her intensely powerful, harrowing and frequently life-risking performances that push her to the edge of her physical and mental limits, she has made an indelible mark on the medium.

For *Rhythm 0* (1974), one of her earliest and best-known works, she declared 'I am the object' and gave up all control over her body to gallery visitors. She placed seventy-two items on a table and invited people to use any of these objects on her body in whatever way they wanted. The objects on offer ranged from a rose, a feather, a pen and honey to a saw, scissors, a whip and even a gun with bullets. Acting as collaborators in the performance, not merely passive spectators, some visitors cut and attacked her, stripping the clothes from her body and holding a loaded gun to her head; others sought to protect her, wiping away her tears. Yet Abramović did not falter. In the end – after six hours – it was the audience members who insisted the performance be stopped over fears for her safety. With the work she offered a stark portrait of the aggressions lurking beneath the surface of society, but also demonstrated the triumph of the mind over such violence.

It is this strength of purpose, running through all her works, that transforms them from a series of repeated actions into exercises in trust, endurance and transcendence. Between 1976 and 1988, she worked with her partner and collaborator Ulay in a series of extreme exchanges: they screamed at each other, inhaled and exhaled into each other's mouths for over an hour, and Ulay held a bow taut with an arrow pointing at Abramović's heart. When they eventually chose to end their partnership, they did so movingly, by each walking from the opposite ends of the Great Wall of China and meeting in the middle to say goodbye.

More recently, Abramović has assumed the role of a spiritual teacher to performance artists and performers alike → see P. She has been developing the 'Abramović Method', a series of mind and body cleansing exercises, and is due to open the Marina Abramović Institute in Hudson, New York. Even after more than forty years of performing, she shows no signs of slowing down.

Ulay and Marina Abramović's *Rest Energy*,
performance for video, 1980

TLC: Tender Loving Conservation
How can we make sure our art survives?

With their white lab coats and all sorts of scientific tools at the ready, conservators strive to preserve works of art for future generations. When it comes to contemporary art, there can be all sorts of strange and unusual challenges. When the Museum of Modern Art in New York was asked by a collector for advice on how best to reattach the peeling label of an Andy Warhol soup can, the chief conservator called the soup company to ask what type of adhesive had been used to fix the label to the can when it was first produced. This may seem pedantic, but it was the key to restoring the can to its original state.

Often conservators border on forensic detectives, chasing leads, unravelling clues and drawing on all kinds of ingenuity. Principally, they look to safeguard the artwork. The key questions are: how can we, and how should we, show this particular work in ten or one hundred years' time? To establish this, they seek to understand the physical mechanisms of change, working to ensure carefully controlled conditions in museum environments and taking measures to repair and protect artworks as necessary. One of the greatest challenges for contemporary art conservators has been the proliferation of synthetic materials since World War II, for which there is only limited knowledge of how they might alter with age. Film, video and computer artworks pose different challenges as technologies become obsolete. Conservation work can therefore vary drastically, calling for a whole variety of highly skilled specialists, from the computer technicians who back up digital art on servers to structural engineers who keep gigantic public sculptures standing or professional paint sprayers whose job it is to re-coat the pristine surfaces of Minimalist sculptures.

All sorts of inventive solutions can be concocted. Kader Attia's *Untitled (Ghardaïa)* (2009), for example, is a multi-part installation that includes a model of the ancient Algerian city of Ghardaïa constructed from cooked couscous. Since the couscous is to be replaced every time it is exhibited, conservators at the Guggenheim, where one edition of *Untitled (Ghardaïa)* is held, worked with the artist to figure out precise cooking instructions

when the piece entered the collection. It was equally important to procure detailed elevation drawings of the building blocks and draw up a set of instructions relating to issues such as pest control and mould while the installation is on show.

Indeed, not all art is intended to survive. The drive to preserve is often at odds with the wishes of artists, who actually want their work to deteriorate. Alternatively, for other works, the slightest degree of wear can disconnect them from the artist's original conception. But then perhaps interventions to keep a work as good as new damage the integrity of the original object. This can lead to a series of tricky, yet important, questions, such as: should the concept take precedence over the authentic object? What does it mean for art if replicas become more commonplace for displaying works that are too fragile to exhibit or have long since deteriorated into states totally unrecognizable from their originals?

Often conservators border on forensic detectives, chasing leads, unravelling clues and drawing on all kinds of ingenuity.

When faced with these dilemmas, being able to decipher the artist's intent is paramount. Luckily, most contemporary artists are living(!), and museum conservators can actively seek their advice through interviews and lengthy questionnaires as soon as a new piece enters their collection. Conservators often work collaboratively across institutions to share information on materials and artists' intentions. In the end, each work is its own special case and deserves some tender loving care, even if that means some conservators have to spend three months of their lives fretting over little bugs in the streets of a couscous town.

When new media becomes 'old' media

LIKE YOUR CAR PHONE, mini-disc player, MySpace account and iPhone 5, most technology eventually conks out and is replaced with something new. Over the past fifty years, conservators have been struggling to keep up with technological developments, as the rapid obsolescence of playback technology has put all art made on outmoded platforms at risk.

Think about it. The analogue television monitor was replaced by the digital LCD flat screen; the Super 8 camera gave way to 16mm to Betacam and then to VHS; VHS video tapes became laserdiscs, DVDs then Blu-rays and more recently pure data on USB sticks or in the 'Cloud'; cassette tapes became CDs, and so forth...Much of the time, the solution has been to 'migrate' video art from one platform to the next, always keeping back-up copies or 'preservation masters', just in case. These days, collectors and conservators make sure to obtain the actual data and original source codes with any new acquisition.

But what to do with works that incorporate now outdated technologies as an integral part of their existence? In the case of Nam June Paik's sculptural works using analogue television monitors, conservators at major institutions worldwide have stockpiled as many of those that remain in existence as they possibly can, so that faulty ones can be replaced. But this can only be a short-term tactic and the conservators of the future will have to come up with alternatives. In other instances, artists have stipulated that when the technology becomes obsolete the work will also cease to exist, such as Cory Arcangel whose early work was made with hacked Nintendo consoles. As with other areas of conservation, the golden rule is to work closely with the artist to establish which part of the art is the art.

Suffice to say that new technologies bring with them a host of new challenges → see G. But a growing breed of conservators dedicated to video, film, audio, software and online technologies are now working together to advance the field and build new strategies. As artists adopt new technologies, it is a matter of urgency that skills of preservation keep pace to ensure the afterlife of our cultural heritage.

Nam June Paik, *Electronic Superhighway: Continental U.S., Alaska, Hawaii*, 1995

Under Construction
What should museums look like?

THE STARK AND EMPTY WHITE ROOM, free of all visual distractions except the work of art, has become a standard so widely accepted that it is now barely even noticeable. In an age when anything can be art, it is the 'white cube' that lends the objects on display their artistic identity → see E. This system of display dates back to the founding of the Museum of Modern Art in New York in 1929. Here the earlier practice of hanging pictures 'salon-style' (close together, one above the other, sometimes reaching to the ceiling) was supplanted by hanging works sparsely at eye-level and in single rows. The idea was to allow the viewer to focus on one work at a time and to maximize purely aesthetic contemplation. Soon, windows were banished so that any semblance of an outside world, daily life and the passage of time disappeared. For film and video, the white cube's counterpart evolved some fifty years later in the form of the cinematic 'black box'.

 This state of withdrawal from the world outside allowed museums to emerge as a space set apart for reflection, and as a symbol of personal and collective transformation through a higher ideal. In this space of encounter, a particular set of norms of behaviour was also instilled. Today's museum-goer is contemplative and solemn, walking slowly through the galleries and speaking in hushed tones. Under the watchful eyes of gallery attendants, he or she obeys the 'do not touch' signs. Seen in this light, it comes as no surprise that similarities have been noticed in the floor plans of prisons, religious temples and museums.

 As the museum interior has been pared back, exterior architecture has become increasingly ambitious and dramatic. In recent years, 'star-chitects' have brought a new dimension to contemporary art museum architecture. These famed architects either convert existing sites (for instance, Tate Modern, London, formerly Bankside Power Station, by Herzog & de Meuron) or build from scratch (for example, the remote Naoshima island in Japan referred to by locals as 'Ando Island', is home to a cluster of contemporary art museums, many designed by the famed architect Tadao Ando). Their spectacular designs use cutting-edge

U

materials and technology to turn the museum building itself into a work of art. This vogue for museum-as-artwork has its roots in Frank Lloyd Wright's 1959 design for the Guggenheim Museum in New York, with its striking sculptural form, spiral ramp and enormous atrium.

This state of withdrawal from the world outside allowed museums to emerge as a space apart for reflection, and as a symbol of personal and collective transformation through a higher ideal.

While today's contemporary art museums may look nothing like their predecessors, these houses of contemporary art by Frank Gehry or Santiago Calatrava are variations on an old theme. Their history stretches back to eighteenth-century Europe, when the collections of the wealthy were displayed in impressive custom-designed halls and galleries that would dazzle visitors, while at the same time giving them a carefully managed image of the collector.

Yet many art critics have raised concerns that the most outlandish art museum designs upstage the art inside. There is little doubt that most of those who fly to Bilbao in northern Spain to visit the Guggenheim Museum are going primarily to see Gehry's shimmering titanium structure. In fact, the power of an artistic institution to transform the international standing of a city is often referred to as the 'Bilbao effect', after its impact on the local economy. Contemporary art museums' ability to turn a city into a global tourist destination has often made them into a pretext for ambitious architecture and urban investment.

As this new breed of art museums with its spectacular and distinctly futuristic appearance multiplies globally, who is to say whether the white cube and black box will be safe from similar transformations? Only time will tell.

Saadiyat Island's
Cultural District

LOCATED JUST 500 METRES (less than half a mile) off the coast of Abu Dhabi, the capital of the United Arab Emirates, Saadiyat Island has garnered much attention since plans were announced in 2006 for its transformation into a global cultural destination. Saadiyat Cultural District is to become home to several brand-new, purpose-built museums.

Each museum will be designed by a leading architect, revealing ambitions to redefine Abu Dhabi's voice in the region and its position in the world. There is the Guggenheim Abu Dhabi, a Frank Gehry design flanked by eleven of his signature conical structures and dedicated to contemporary art; the Performing Arts Centre by the late Zaha Hadid (the most famous female architect ever), designed to draw visitors upwards to performance spaces described by Hadid as 'fruits of a plant'; the Maritime Museum, by self-taught Japanese architect Tadao Ando, whose design is inspired by the shapes created by a sail full of wind; the first ever outpost of Paris's iconic Louvre, by the French architect Jean Nouvel; and, finally, Zayed National Museum by Norman Foster – the brains behind the Gherkin building in London – which introduces the history and culture of the UAE and Sheikh Zayed (1918–2004), the UAE's first president and the driving force behind its formation.

Yet, proceedings for the estimated $28 billion construction of this arts district have not been without controversy. Human Rights Watch drew attention to the abuse of migrant workers from South Asia in 2009 and 2015, pointing out the irony in the fact that the island's Arabic name literally translates as 'the island of happiness'. While such protests have forced the UAE to reform Emirati labour laws and policies, New York University Abu Dhabi (which opened its campus in the Marina District in 2010), the Louvre and the Guggenheim have continued to come under attack for the low wages paid to migrant labourers and harsh working conditions. These are issues they continually seek to address, in acknowledgment of a shared responsibility for the decisions that shape our culture's future.

Architectural rendering for Louvre Abu Dhabi designed by
Jean Nouvel Architects and to be built in Saadiyat Island's
Cultural District, Abu Dhabi, United Arab Emirates

Visitor Activated
Can I touch it?

It's easy to imagine the sense of child-like wonder that overtook visitors when they encountered *Anthropodino*, the spectacular site-specific installation artwork created for the Park Avenue Armory, New York, for a month in 2009 by Brazilian artist Ernesto Neto. Looking like something that would be more at home on another planet than in an art gallery, this enormous structure comprised a central tent-like dome with blue- and pink-tinted tunnels, reaching outwards like tendrils. The open ends of these tubular passageways invited visitors to step into a labyrinthine interior. Around the outside, people were encouraged to kick off their shoes and relax on an enormous purple beanbag, or lie inside a red igloo scented with chamomile and lavender, or sink into a pool filled with plastic balls. Hanging above was a gigantic canopy of white fabric from which dozens of fabric tubes descended, some filled with aromatic spices.

Today, installation art like Neto's *Anthropodino* is one of the most ubiquitous forms of contemporary art. While the term 'installation' was originally used to describe how works were arranged (that is, installed) on the wall or in an exhibition space, by the late 1950s or early 1960s it had come to denote emerging art practices that used a diverse range of media to construct temporary or permanent environments. In an installation artwork, objects or materials are to be viewed not as individual works, but as an entire ensemble. There is no one fixed formula when it comes to this. While some installations are designed to be walked around in and contemplated, others restrict the view to what can be seen from a doorway.

More and more, artists are using installation art to transform the way visitors engage with an artwork, creating works where audience participation is crucial in activating and revealing their meaning. In fact, the Russian artist Ilya Kabakov, one of the most important proponents of installation art, went so far as to compare installation art to a theatre where the viewer is the actor, the artist is the director and the artwork the stage.

The materials used can vary widely depending on the artist's intended meaning for the work and desired experience for the viewer. Each element might be symbolic, encouraging visitors to play detective and piece together the clues, while performance, sound and moving image may be incorporated to create otherworldly settings. The Swiss artist Pipilotti Rist, for instance, often transforms the exhibition venue into a gigantic multimedia space where visitors can spend hours lying on soft sculptural islands, surrounded by surreal moving images of pink flowers and naked body parts. In these works, art becomes a situation instead of an object. And this goes some way towards explaining why we often find it so difficult to describe our experience of an installation and why photographs never seem to do it justice. More often than not, you just had to be there.

More and more, artists are using installation art to transform the way visitors engage with an artwork, creating works where audience participation is crucial in activating and revealing their meaning.

For Neto, it is the interplay between visitors that makes his installations come alive. He describes his audiences as individual 'cells' that embody different cultures, societies and histories, and his works as bringing these together. Yet, on a very basic level, the experience of *Anthropodino* was more primal. The aroma of the spices hit you before your eyes could adjust to the playground of blues and pinks that lay ahead. As the work showed, there is perhaps no better way to experience an installation artwork than to kick off your shoes and jump in.

Yayoi Kusama,
The Obliteration Room,
2002–present

IMAGINE WALKING INTO A COMPLETELY WHITE ROOM. The kitchen counter, the sofa, and even the TV and the kettle on the hob are white. No, you have not just stepped into a mental hospital; it is the Japanese artist Yayoi Kusama's interactive installation *The Obliteration Room*. And how is it interactive? Well, in your hand is a set of stickers, each one a brightly coloured dot of a different size and Kusama wants you to stick these little guys anywhere and everywhere!

For Kusama, these dots are a way of understanding the universe. In her words: 'Our earth is only one polka dot among a million stars in the cosmos. Polka dots are a way to infinity. When we obliterate nature and our bodies with polka dots, we become part of the unity of our environment.' This idea of 'obliteration' was first conceived in the 1960s, when she began covering herself and others entirely in dots for her 'self-obliteration' acts. In *The Obliteration Room*, Kusama invites you to participate, to collaborate not only with the artist, but also with each other, to transform – obliterate – the space into a blur of multicoloured dots. For her solo show at David Zwirner Gallery in New York in 2015, she recreated this installation inside a small prefabricated American suburban house constructed within the gallery space. The experience is akin to another well-known piece by Kusama, the *Infinity Mirror Room*, where you enter alone into a contained space panelled wall to wall and floor to ceiling with mirrors. The flickering lights that hover within are reflected infinitely, leaving you feeling like you are floating in space and inviting you to lose yourself and take your place as but one star among millions.

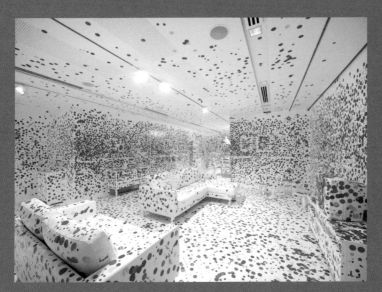

Yayoi Kusama, *The Obliteration Room*, 2002–present.
Collaboration between Yayoi Kusama and Queensland Art Gallery

WTF?!
What on earth
am I looking at?

Contemporary art can be hard work. Everyone at one point or another has walked into an art gallery, taken one look at what's on display and thought, 'What The F$@# is that?!?!?!' And it may be that the little texts on the walls confuse things even more, leaving you feeling like you just don't get it. Unfortunately, this experience is quite normal.

The first step to understanding contemporary art is to remember that whatever it is you're looking at is not representative of *all* contemporary art. There is a whole world of art out there and so much is being made all the time: sculpture, painting, performance, conceptual, immersive, repulsive, calming, challenging, mind-blowing, overwhelming and, to be frank, underwhelming. And all of it – *all of it* – is contemporary art. So what you're looking at is just a tiny fraction of what is out there, and maybe, as luck has it, this isn't the kind of contemporary art you like or that speaks to you. Maybe you would respond more to a work that draws more on the artist's own personal experiences or something that is a little more politically charged. This might just not be your kind of thing.

Figuring out what you're looking at is made all the more complicated by the fact that, because there is so much and because it is all new, for the most part there hasn't been enough time for the good to be separated from the bad. That is the exhilarating, and terrifying, thing. Nobody is quite sure what they are looking at and a good chunk of it may very well be crap. But let's not dismiss anything too quickly! Especially as so much contemporary art is about provocation, challenge and disrupting expectations. Even when we feel sure of our opinions, sometimes it's our eyes that need to catch up. The legendary art critic Clement Greenberg famously said: 'All profoundly original art looks ugly at first.'

We also need to think about how we define what art is good and what's bad, and there is no hard and fast rule here, just a general consensus. Some widely accepted markers of good art include the idea that art should advance the narrative of art history, or make you feel a range of different emotions at once, or resonate with you long

after the first encounter. But everyone has their own criteria. It can be a relief to remember that what you recognize as 'good art' and the art that you like don't have to be one and the same thing. Matters of taste don't always have to be as serious as some terribly boring critics and frightfully sincere artists would have you think. Everyone has their guilty pleasures.

Not being able to understand contemporary art doesn't make you stupid. Having said that, it doesn't make the art stupid either.

The next step is not to take it so personally. Not being able to understand it doesn't make you stupid. Having said that, it doesn't make the art stupid either. As with literature, music or dance, some of it is simple to grasp, but other bits are complicated and require effort to be fully appreciated. There are frames of reference that take time to hone. Just as we can understand Picasso's *Les Demoiselles d'Avignon* (1907) as advancing the language of painting by incorporating different perspectives into one picture plane, or as a rupture with the tradition of Western painting because it depicts women in a way that is neither idealized nor submissive, or even as representing the artist's fear of contracting disease after several brothel visits, so we can read *Errotin, le vrai lapin* (Errotin, the true rabbit) (1995), a work that involved the artist Maurizio Cattelan dressing his gallerist Emmanuel Perrotin as a giant penis-rabbit, as spotlighting the mega-dealer's rumoured playboy ways, as a means of frustrating any attempt at serious commercial dealings, or as a riff on the shock tactics so often utilized by performance artists → see O.

Moreover, there are specific skills to unpicking visual material that only develop by exposure, but, on the whole, these are skills we possess already. We make decisions daily about everything, from the colour of our socks and whether we like the look of that

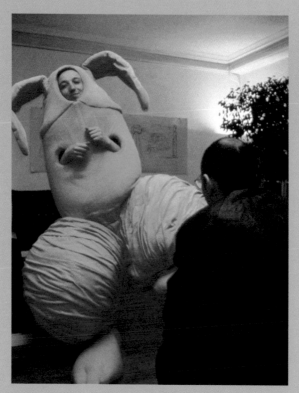

Maurizio Cattelan, *Errotin, le vrai lapin*
(Errotin, the true rabbit), 1995

dessert to whether or not to pay attention to that ad in our browser – often without thinking. These are aesthetic decisions, but also snap judgments about whether a concept is delivered in a way that speaks to us and gets our attention. So relax! Don't be afraid to bring these skills and apply them when you have your next WTF?! moment. And the more contemporary art you see, the more you read, the more time you give it, the more you get from it.

A good place to start is by choosing one artwork or artist that piques your curiosity and learning a bit more about that one thing. If you are intrigued and have an open mind, there is plenty of help available. In museums, there are wall texts, brochures, guided tours, exhibition catalogues and often attendants on standby, who may know a good deal more than you expect (and would probably be delighted to talk to someone). Commercial galleries aren't so helpful with labelling and may be staffed by snooty characters, but you can always ask for a press release at the front desk and this should explain some of the thinking behind what's on view. At the very least, a price list will give you a list of works with titles, what they're made of and what they're being sold for. Then, of course, there is the Internet with a whole wealth of resources beyond Wikipedia, from artists' personal websites and their gallery pages to YouTube interviews, video art you can watch on Vimeo and potted histories recounted on museum websites. All these resources are out there for the taking.

The main thing is not to be afraid to ask questions. Not just of other people, but of the artwork itself. If this chapter title is anything to go by, you've probably asked one already. What does this piece of art do? Does it draw you towards it or push you away? Why? What do you think it was like for the artist to make it? Can you pinpoint why you like it? Or why you don't? Contemporary art exhibitions are prime date spots precisely because there is a lot to talk about! And so much more can emerge through conversation. So don't be afraid to talk it out and trust your judgment. But don't force it. At the end of the day, we all have bigger problems than sounding stupid in front of a giant penis-rabbit.

International Art English

WHY IS IT SO DIFFICULT to find plain English in the art world? For many of us, reading a wall text, press release or exhibition catalogue is often an incredibly frustrating experience. Instead of finding answers and making sense of the work, your efforts are rewarded with a slippery chaos of descriptors and embellishment. You might understand every word independently, and yet they are connected in such a way that entire paragraphs seem to skirt meaning altogether. Wading through the onslaught of words, making sense of it seems so near and yet so far.

In 2012, artist David Levine and sociologist Alix Rule conducted a study on this form of 'Artspeak', using press releases from the Internet mailing list e-flux, which circulates roughly three announcements a day about exhibitions from all over the world. Taking the previous thirteen years of mail-outs as their sample, they conducted lexical, grammatical and stylistic analysis to identify patterns of linguistic usage in a unique language they named 'International Art English' (IAE).

So what are its defining features? IAE loves to invent nouns: 'potential' becomes 'potentiality', 'experience' becomes 'experiencability'. In IAE, the longer the word, the better: why should artists 'use' something when they can 'utilize' it? Then there is a compulsion towards hyperbole: an artist's work is never simply thought-provoking but, as one recent press release put it, 'dissolves our perceptions of the real and the virtual, place and time and the nature of memory and its loss'. Oh, that's another thing, a tendency to list opposites – the work at once 'exposes and obfuscates', it 'blurs the boundaries' between 'internal psychology and external reality'.

No one in the art world can claim immunity. At some point, all of us have been guilty of speaking in what sounds like 'inexpertly translated French', as Levine and Rule put it. But it would be too hasty to dismiss all Artspeak as gobbledygook. There is a lot of good writing out there and sometimes a long word is used because a long word is required. Really good writing can be as enlightening as it is challenging. And that's a lovely IAE pairing, if ever there was one!

inverts

negative space
encompasses

futurity
globality

introspection

liminal

dialectics

tensions
multitude

autonomy
platform
critical

homogeneous

hierarchy
spans
institutional

explores traces
aporia

subverts
totality

autonomy
subjectivity

hybridity

potentiality

perception
infinite

gestural
hegemony

existential

platform
rupture
juxtaposition

cultural imaginary
entropy

void

materiality

X Marks the Spot
What is the role of public art?

For 16 days in the summer of 2016, at Lake Iseo in Italy, the general public was able to walk for about 3 kilometres (almost two miles) on water (literally!), atop 200,000 floatable cubes covered in bright yellow fabric that connected the shore to a tiny island on the lake. Titled *The Floating Piers* (2014–16), this public artwork, conceived by the artist duo Christo and the late Jeanne-Claude, became one of the most Instagrammed images of the summer (#FloatingPiers). 'Like all of our projects, *The Floating Piers* were absolutely free and open to the public,' explained Christo. 'There were no tickets, no openings, no reservations and no owners. *The Floating Piers* were an extension of the street and belonged to everyone.'

For many, public art still means traditional war memorials and statues of national heroes adorning city squares and parks, and though it continues to serve this commemorative and decorative function, it is safe to say contemporary art has breathed new life into this tradition. Whether it is initiated by a local government who want to activate a public space through art or by the artists themselves, the realization of a public work of art is an arduous and long process that requires a team effort on a truly epic scale. For example, the idea for *The Floating Piers* was conceived all the way back in 1970, but it took the artists 46 years to make it happen, after attempts in South America and Japan failed. In fact, waiting has become a hallmark of Christo and Jeanne-Claude's visionary and short-lived artworks, often reflected in the dates of their titles: they waited 24 years to be granted permission by the German government to wrap the entire Reichstag building in Berlin in fabric for *Wrapped Reichstag* (1971–1995); it took them 26 years of meetings, consultations and public hearings, during which they endured feasibility reports, petitions and angry letters of protest, to get the green light to install *The Gates* (1979–2005) in New York's Central Park.

So why go to all the trouble? Indeed, it certainly isn't all hashtags and 'likes'. In the case of *The Floating Piers*, the hassle of maintaining the work meant that it wasn't welcomed by everyone. Although the installation was paid for by the artists through the

sales of their work, the local authorities had to contend with overcrowding, as well as health and safety issues, and had to turn some visitors away. A number of locals even complained about the costs of evacuating stranded tourists and cleaning up after them.

Pursued in the name of the 'public', how much is the public actually considered? In other words, what's in it for the average Joe?

In fact, public art almost always elicits mixed responses. Protests are frequently made decrying the waste of public funds, the ruining of public spaces, or worse, the offending of community values by government authorities. When the American artist Paul McCarthy put up his giant inflatable *Tree* (2014) in Paris, right-wing protesters condemned the sculpture that resembled a sex-toy as an act of humiliation towards the city. Within ten days, the inflatable work had been deflated by an unknown member of the Parisian public. Scandalous as this may sound, this story strikes at the heart of the real issue with public art: pursued in the name of the 'public', how much is the public actually considered? In other words, what's in it for the average Joe?

The fact is, any art in a public space is not going to be everyone's cup of tea. But however you might feel about public art, it is guaranteed to generate conversations between local communities and strangers alike, bringing people together through the experience of something extraordinary → see A. Permanent works can foster a prolonged sense of civic pride, as Anish Kapoor's *Cloud Gate* (2004) does in Chicago. The mirrored curves of this iconic kidney bean-shaped sculpture are now a staple snap stop for any tourist in the city. As Germano Celant, the curator of *The Floating Piers*, put it: 'These projects are a kind of dream, one that everybody can understand and everybody can participate in.'

Banksy for all

THE CHANCES OF YOU recognizing Banksy even if he walked right into you on your local high street are next to zero, but we'd bet good money that you'd instantly know one of his stencilled graffiti works on the backstreets of Brick Lane in London. His dark-humoured social commentaries have been featured across walls and under bridges in cities all over the world: two policemen kissing on the side of a pub in Brighton, a street-fighter wielding a Molotov cocktail that is in fact a bouquet of flowers on a wall in Jerusalem, two soldiers looting following the devastating Hurricane Katrina in New Orleans.

The universal appeal of his work is indisputable. The subject matter is often topical, resonating with challenges facing the surrounding community, as well as tapping into broader issues such as police brutality or our tech-obsessed contemporary culture. The immediate legibility of his visual language has meant that his street art (which is in fact illegal, since it is considered a form of vandalism) has proved more popular than many formally commissioned works of public art. On a number of occasions, communities have even fought back against attempts by local authorities to remove Banksy's so-called vandalism, prompting disputes over the ownership of pieces of walls.

And although he may not be highly regarded within the 'serious' art world, he has certainly captured its attention with solo shows at major museums, celebrity collectors and auction sales. Banksy has made great strides in raising the profile of 'street art'. Indeed, the Banksy phenomenon has raised interesting questions. Who is street art made for? Who protects it and who determines its future? Who owns a work of street art? And, ultimately, who can lay claim to the street?

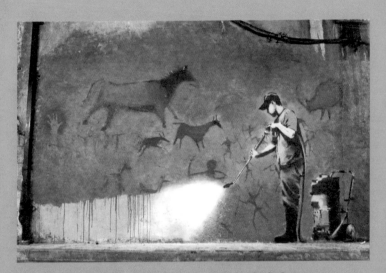

Banksy's *Washing Away of Cave Paintings* discovered on Leake Street in London in May 2008, and painted over by August 2008

Yesterday, Today and Tomorrow

How is the art world changing?

THESE DAYS, the rate of technological progress has accelerated such that it seems like the future is coming for us faster than ever. A mere fifty years ago, no one would have predicted that the advent of the Internet would transform our lives so fundamentally. But what has this meant for art and the art world? And what does the future hold? Only by looking at the ways that things are changing now can we begin to imagine what's still to come.

There can be no denying it: 'the digital' is a fundamental marker of our era. And while the World Wide Web may have been around for more than twenty-five years now, we have only just begun to see its impact on art. A new generation of artists is beginning to emerge – a generation that has grown up with the Internet and for whom living life both on- and off-line is second nature. As the digital seeps into all aspects of life, so too is it reflected in art of all media, from paintings of online encounters to sculptures 3D-printed on demand. In fact, the ideals of much early Internet art that looked to engage audiences directly in their own homes still hold true and there is plenty of untapped potential for art in the age of the smartphone → see G. And just wait until artists really get going with virtual and augmented reality!

The Internet has also impacted the way art is made available and accessible. Museums are bringing more varied content to much broader audiences by expanding their Web presence to include behind-the-scenes blogs, Instagram posts, and video interviews with artists and curators, often making these available in different languages as well. On the commercial side of things, Web sales platforms are proliferating. Although online art sales are yet to take off, the day when it becomes commonplace for art lovers to download a piece of video art from the Internet may be just around the corner.

But being constantly connected, scrolling through masses of information, clicking 'like', and swiping left and right while sitting on your sofa can leave you feeling lacking. It can ignite a desire to move in the opposite direction, towards the intimacy of life offline. And the art world has responded to this too, as is

reflected in a renewed emphasis on festivals and events as opportunities to visit museums and engage with others. Performance → see S is also being incorporated into the daily activity of museums, adding a more human aspect to the visitor experience and getting people to interact with one another. As with installation art, performance is something that can only be experienced in person – that can only be related to physically. It's these kinds of works that are being given more prominence.

What we see today is the restructuring of the Hows, Wheres and Whos that shaped the art world until now.

All this is part of a broader trend towards more personalized content across the art world. Museums now tailor their approach according to specific audiences → see K. While flashy auction sales are still important, private sales, where auction houses approach key collectors directly and sales are brokered behind closed doors, are on the rise. Alternative models of art fairs are also starting to chip away at the dominance of the market by a handful of mega-fairs. Often these events are much smaller and by invitation only, with just a select group of collectors in attendance. A number of galleries are even experimenting with gallery swaps, where they switch spaces with a gallery in another country for a short time to enable them to approach collectors in other parts of the world.

In a sense, what we see today is the restructuring of the Hows, Wheres and Whos that shaped the art world until now. But one thing's for sure: as the Internet continues to be integrated into our daily lives, we are only beginning to understand how our faculties of perception and modes of processing information are changing. The ways we see and interpret art are transforming rapidly, perhaps more quickly than ever before, and to a degree we can't yet know. Welcome to the future – it's time for your upgrade.

Funding

THERE'S NO WAY AROUND IT, art costs money. And whether you're making, buying, displaying or supporting art, funding is crucial for keeping the art world afloat.

For many artists, sales may not bring in enough to cover fabrication, art materials, studio rent and travel, let alone the cost of living. In such cases, artists may seek funding from not-for-profit organizations, both public and private, most often in the form of prizes (money), grants and fellowships (money for a specific project) and residencies (less money, but rent-free accommodation in a nice place to make art). These opportunities vary significantly from country to country and foundation to foundation. Although they tend to be available by open application, candidates usually have to meet certain eligibility criteria, and submit a detailed proposal and budget. However, the most respected fellowships, such as the five-year MacArthur grant, are usually only by nomination. The enormous prestige associated with these awards is often matched by the cash payout, which can reach six figures.

Let's not forget, museums need money too. From insurance, shipping and building new walls, to conservation and public programmes, the costs can be vast and ticket sales simply don't cover everything. This means that even the biggest museums are constantly fundraising through channels as various as corporate partnerships, patrons' circles and memberships. Museums rely heavily on their development teams to identify the right sponsors and apply for philanthropic grants all year round to raise funds for wish-list exhibitions and projects.

But there's no such thing as a free lunch! Support inevitably comes with strings attached and even government funding has its restrictions. Nonetheless, whatever shape or form it comes in, what really makes these sources of funding so important is that they represent a faith in the value of creativity and enable artists to continue to make work that has the power to inspire. Fund fresh arts, not old farts!

Artist Fee Plumley carries a protest sign at the Arts Industry Council of
South Australia rally against funding cuts at Parliament House in Adelaide,
Australia, 19 April 2016

Zoning Out
Why bother?

CONTEMPORARY ART often seems trapped in an endless cycle of production and consumption, its value measured in terms of a dollar sign (what is it worth?), appeal (does it look good?), radicality (does it push boundaries?) and experience (how does it affect me?). But what could art be, and what could it do, if it were to challenge the parameters that purport to dictate its reason for being?

Across the world, many artists have used unorthodox methods to show that art can be more than this. A growing number of artists are opting to work with communities rather than make 'artworks' as such. These activities, often referred to as 'social practice', move the conversation away from the finished product to the process itself → see I. Take Jennifer Allora and Guillermo Calzadilla's *Chalk* (1998–present), for example. For this work, the duo placed giant pieces of chalk in public places and invited people to draw and write freely, as they pleased. In such cases, applying categories or discipline-specific terms like 'sculpture' and 'performance', or even 'art', feels forced at best and redundant at worst.

Then there are attempts to expand the scope of art and connect with other fields of study, including science and technology, ecology and geology. Such collaborative and interdisciplinary approaches to art-making are becoming established through residencies and programmes at research institutes including the European Organization for Nuclear Research (CERN) and the Wellcome Trust, a biomedical research charity based in London. For her residency at the Wellcome Trust (2012–13), British artist Katie Paterson immersed herself in genomics, examining fossil records and analysing the DNA of various species to trace the development of life on Earth. An increasing number of artists have also dedicated their practice to learning about the impact of human activities on the earth, through projects ranging from long-term research to environmental activism, in the hope that art can point the way to a more ecologically sustainable future. For instance, the Danish-Icelandic artist Olafur Eliasson's wake-up call to the world in 2014 was twelve blocks of ice transported

from Greenland to Denmark's capital, Copenhagen. Plonked down in the middle of the square in front of City Hall, the ice melted away, forcing passers-by to witness the effects of global warming.

> **What could art be, and what could it do,
> if it were to challenge the parameters that
> purport to dictate its reason for being?**

While such attempts to push the bounds of art as we know it may seem all nice and dandy in theory, the sceptic in us will lament that art institutions and the market always catch up and find a way to engulf and neutralize such pursuits. Duchamp's once scandalous readymades now seem just as at home in a fancy art museum as an oil painting by Rembrandt, while performance art can now be bought and sold like any other artwork. In today's world of contemporary art, nothing seems improbable. But that doesn't stop these works from having a tremendous and palpable charge in the here and now. Perhaps the key lies in the act of constant writhing, of placing faith in art's potential for radical possibility, in wanting to believe. Aren't we in the business of imagination, after all?

Theaster Gates, *Dorchester Projects*, 2009–present

It all started in 2009 with a bungalow on South Dorchester Avenue in Chicago's South Side, an area known for its high crime rate. Once the American artist Theaster Gates had finished with it, it had been transformed into the 'Archive House', home to 14,000 volumes of art and architecture books from a closed-down city bookstore and a 'Soul Food Kitchen' for the neighbourhood community. Using the leftover scrap wood, Gates created artworks that he could sell, generating income, which was then used to purchase an abandoned former sweet shop on the same street. Inside this one, he put all the vinyl LPs from a local record store that had gone out of business and named it the 'Listening Room'.

Since then, Gates has bought and restored half a dozen other vacant properties as part of what has become his *Dorchester Projects*. The restorations are carried out using repurposed objects and parts from the existing architecture, and the projects are financed by the sale of artworks created from the materials salvaged from the interventions. In 2013, Gates bought the long-abandoned Stony Island Bank building for $1, when it was only days from demolition. To raise the $3.7 million necessary for its renovation, Gates sold 'Bank Bonds' created from the marble tiles taken from the bank's former urinals – a homage to Duchamp's urinal – inscribed with the phrase, 'In art we trust'.

Dorchester Projects has since become an incubator for community artists and an informal gathering space where the public can meet for dinner, attend performances and engage in discussions about art. Gates's project has brought artistic and social change to the South Side, empowering those involved to claim a stake in preserving and rebuilding their history and surroundings. Nearby, he is also working to turn a public-housing project into a mixed-income complex that provides homes for both low-income families and emerging artists. Rebuild Foundation, the not-for-profit organization Gates created to run the scheme, has also begun similar projects in other parts of the US. The ever-expanding *Dorchester Projects* shows how art can change lives. It can all start with one single tile. In art we trust.

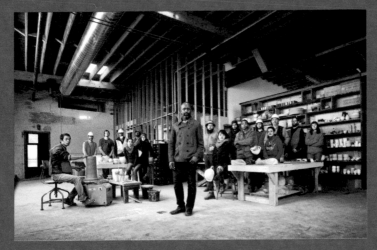

Theaster Gates with employees and artists in his pottery studio,
inside a converted beer warehouse on Chicago's South Side

Delve Deeper
What if I want to know more?

We have drawn on a wealth of sources in putting together this book. Listed here is a brief selection should you wish to learn more. Almost all the articles included here were available online at the time of publication.

* indicates a source we have quoted.

Key Resources
Art21.org – a fantastic series of short films about different contemporary artists and their studios.
Artforum.com/guide – tells you what's on at galleries around the world and includes monthly critics' picks. Also available as a handy app!
Artsy.net magazine – the online magazine component of this Web art-sales site has excellent up-to-the-minute articles on contemporary art and the market. There's an excellent podcast too.
e-flux.com – *the* mailing list to sign up to if you want to know all the goings-on of the art world.... You'll get a billion emails a day but will never be out of the loop!
Museum websites tend to have masses of information about exhibitions on view and the works in their collection, but also other resources such as video interviews and art-historical timelines.

A **Art21* episode 'Change', released 14 April 2012 and available to view on the website, features Catherine Opie, El Anatsui and Ai Weiwei, and explores how artists can respond meaningfully to our changing world.
* E. H. Gombrich is quoted from *The Story of Art* listed in B.
Will Gompertz, *Think Like an Artist ... and Lead a More Creative, Productive Life*, 2015.

B Hal Foster, Rosalind Krauss, Yve-Alain Bois and Benjamin Buchloh, *Art Since 1900: Modernism, Antimodernism, Postmodernism*, 3rd edition, 2016 – a year-by-year chronicle of the important moments in twentieth-century art.
E. H. Gombrich, *The Story of Art*, first published in 1950 and now in its 16th edition – the *definitive* guide to the history of art as we know it. Expect to begin with the prehistoric and end with Modern art.

C Julieta Aranda, Brian Kuan Wood, Anton Vidokle (eds.), *e-flux journal: What is Contemporary Art?*, 2010 – lots there if you're really interested, but not for the faint-hearted...
Lauren Collins, 'Profile: The Question Artist: Tino Sehgal's provocative encounters', *The New Yorker*, 6 August 2012.
Jörg Heiser, *All of a Sudden: Things That Matter in Contemporary Art*, 2008 – a really great journey through the history of contemporary art.

D Tara Cranswick (ed.), *Artists' Survival Guide*, 2013 – a practical guide to making, showing and selling work.
James Elkins, *Why Art Cannot Be Taught*, 2001 – includes an in-depth section on conducting critiques for artists and educators.
N. Elizabeth Schlatter, *Museum Careers: A Practical Guide for Students and Novices*, 2008.

E 'You Don't Need Great Skill to be a Great Artist: The Debate', a short video uploaded to YouTube by *Hong Kong Tatler*, 4 July 2010 – Antony Gormley, Hans Ulrich Obrist and others weigh in on the question. Worth a watch despite the cheesy music!
* Manzoni's letter to the artist Ben Vautier in December 1961, included in Freddy Battino and Luca Palazzoli, *Piero Manzoni: Catalogue raisonné*, 1991.
Germano Celant, *Piero Manzoni*, 1972.

F The Venice Biennale website provides a thorough history, but check out the video 'Behind the Biennale: A Short History of the World's Most Important Art Exhibition' on the *Artsy* website for a more concise and fun introduction.
Fairs and biennials produce exhibition catalogues for each iteration.

G The full series of Evan Roth's *Internet Landscapes: Sydney* is available at http://landscapes.biennaleofsydney.com.au.
Michael Rush, *New Media in Art*, 2005, and Rachel Greene, *Internet Art*, 2004, both from Thames & Hudson's *World of Art* series, cover everything you need to know.
Edward A. Shanken (ed.), *Art and Electronic Media*, 2009 – a really comprehensive overview.
Visit etoy.com for more info about etoy.CORPORATION.

H * The Guerrilla Girls have a great website: guerrillagirls.com.
* Jean-Hubert Martin's preface, *Magiciens de la Terre* (the Pompidou Centre exhibition catalogue), 1989.
Linda Nochlin's seminal essay 'Why have there been no great women artists?', 1971.
Jerry Saltz and Rachel Corbett, 'The Reviled Identity Politics Show That Forever Changed Art', *New York Magazine*, 21 April 2016.
* Listen to Fred Wilson speaking about *Guarded View* (1991) on the Whitney Museum of American Art's audio-guide page available on the website, or download the transcript.

I Julie Ault (ed.), *Felix Gonzalez-Torres*, 2006.
* Martin Creed quoted in *The Turner Prize*, as listed in L.
* Maria Eichhorn explained her practice for *Artforum*'s '500 Words' feature, 14 April 2016.
Tony Godfrey, *Conceptual Art*, 1998.
* Sol LeWitt, 'Paragraphs on Conceptual Art', *Artforum*, June 1967.
Alexandra Munroe with Jon Hendricks, *Yes Yoko Ono*, 2000.
* Tim Rollins's interview with Felix Gonzalez-Torres in William S. Bartman (ed.), *Felix Gonzalez-Torres*, 1993.

J Adrian George, *The Curator's Handbook*, 2015.
Jens Hoffmann, *(Curating) From A to Z*, 2014.
Anything by Hans Ulrich Obrist! *A Brief History of Curating*, 2008, and *Everything You Always Wanted to Know about Curating: But Were Afraid to Ask*, 2011.

K Rika Burnham and Elliott Kai-Kee, *Teaching in the Art Museum: Interpretation as Experience*, 2011. Not an easy read, but it is the best book on this if you're really into it.
Dany Louise, *The Interpretation Matters Handbook: artspeak revisited*, 2015 – this is also pretty relevant for W.
Nicholas Serota, 'The 21st-century Tate is a commonwealth of ideas', *The Art Newspaper*, 5 January 2016.

L *Art Review*'s annual 'Power 100' list ranks the most influential people of the year – who will come out on top?
Virginia Button, *The Turner Prize: Twenty Years*, 2003.
Tate website page on the Turner Prize promises to tell you everything you need to know about the prize.

M The *Artsy* website has a great four-part series: 'The Art Market, Explained'.
Arthur Lubow, 'The Murakami Method', *The New York Times*, 3 April 2005.
Katy Siegel and Paul Matick, *Money (Art Works)*, 2004.
Sarah Thornton, *Seven Days in the Art World*, 2008 – this international bestseller takes you on a whirlwind journey through the art world. The chapter that goes behind the scenes at Christie's auction house is fascinating!
* Andy Warhol, *The Philosophy of Andy Warhol: From A to B and Back Again*, 1975.

N Many major cities have free art maps that plot out the locations of local galleries. These are often available at gallery front desks. See also *Artforum*'s online guide.
Robin Pogrebin, 'How a Dealer Prepares for the "Most Important" Art Fair of the Year', *The New York Times*, 9 June 2016.

O * We quote Mona Hatoum from E. Jane Dickinson, 'Body of Work', *The Independent*, 31 July 1998, and 'Mona Hatoum by Janine Antoni', *BOMB*, Spring 1998.
See also the catalogue to Hatoum's 2016 retrospective at Tate Modern.
The New York Times has a great online discussion forum bringing together critics, artists and readers: 'Shock Value: Does art retain the power to shock? Must artists contrive to provoke?'
* 'Santiago Sierra by Teresa Margolles', *BOMB*, Winter 2004.

P * Lady Gaga's 'Applause', from the album 'ARTPOP'.
* Jerry Saltz, 'In conversation: James Franco – Can the art world take James Franco seriously?', *New York Magazine*, 18 April 2016.
'My Beautiful Dark Twisted Fantasy' album, because Kanye West can speak for himself. All you need to do is listen to the lyrics while looking at the album cover...
* Kanye West quoted in Nate Freeman, 'Kanye West Would Trade His Grammys to Be in An Art Context: The Rapper Discusses His New Steve McQueen-Directed Video at LACMA', *ARTNEWS*, 27 July 2015; Jon Caramanica, 'Behind Kanye's Mask', *The New York Times*, 11 June 2013; 'Kanye West speaks to the Oxford Guild', uploaded to YouTube by theoxfordguild on 7 December 2015.
Jay Z's 'Picasso Baby', from the album 'Magna Carta... Holy Grail'.

Q Nina Simon, *The Participatory Museum*, 2010.
Most museums' acquisitions policies are available to view on their websites. For a taste, see the 'Collections Management Policy' on the website of the Museum of Modern Art, New York.

R * Associated Press, 'Ai Weiwei sets up studio on Greek island to highlight plight of refugees', *The Guardian*, 1 January 2016.
Ai Weiwei, Tim Marlow, et al., *Ai Weiwei* (the Royal Academy exhibition catalogue), 2015. You can also read Ai's 'digital rants' in Lee Ambrozy (ed. and tr.), *Ai Weiwei's Blog: Writings, Interviews, and Digital Rants, 2006–2009*, c. 2011.
* Tania Bruguera's press release 'Cuban artist will performance [sic] on Havana Square' can be found on her website: taniabruguera.com. See also the New York City Mayor's Office for Immigrant Affairs' press release about her appointment as its first artist-in-residence.
Claudia Mesch, *Art and Politics: A Small History of Art for Social Change Since 1945*, 2013.
* *The Yes Men are Revolting*, 2014 – a feature-length film about the Yes Men's activities.

S Klaus Biesenbach (ed.), *Marina Abramović: The Artist is Present*, 2010 – this is
the catalogue to her solo show at the Museum of Modern Art. There's also a film.
* RoseLee Goldberg quoted in the *New York Magazine* article as listed in H.
Jens Hoffmann and Joan Jonas, *Perform*, 2005, from Thames & Hudson's
Art Works series. It's an exhibition in the form of a book!

T Oscar Chiantore and Antonio Rava, *Conserving Contemporary Art: Issues, Methods,
Materials, and Research*, 2012 – includes example artist interviews.
mattersinmediaart.org is a collaborative project across several museums working to
aggregate a shared online resource with advice on the preservation of media art. The
Guggenheim's conservation website also provides an excellent glimpse into the field.

U Carol Duncan, *Civilizing Rituals: Inside Public Art Museums*, 1995 – for the
academically inclined.
Victoria Newhouse, *Towards a New Museum*, 2006 – the sections on 'The Museum
as Entertainment' and 'The Virtual Museum' are particularly useful and it also looks
great on your coffee table.
Chris van Uffelen, *Contemporary Museums: Architecture, History, Collections*, 2011.

V Claire Bishop, *Installation Art: A Critical History*, 2005 – Bishop's the expert here!
Frances Morris (ed.), *Yayoi Kusama*, 2012. This is the catalogue to her solo show at
Tate Modern.
* Jess Wilcox, 'Anthropodino: A conversation with Ernesto Neto', *Art in America*,
27 May 2009.
* Kusama quoted in Jud Yalkut, 'Polka Dot Way of Life (Conversations with Yayoi
Kusama)', New York Free Press, vol. 1, no. 8, 15 February 1965.

W * Clement Greenberg, 'Art', *The Nation*, 7 April 1945.
Nancy G. Hiller, *Why a Painting Is Like a Pizza: A Guide to Understanding and Enjoying
Modern Art*, 2002 – possibly the best book title ever and she makes a good point!
* Alix Rule and David Levine's International Art English, *Triple Canopy*, Issue 16,
'They Were Us', 13 July 2012.
Check out the artist group BANK's *Fax-bak* series of marked-up gallery press
releases for an entertaining look at the failures of art writing.

X Banksy, *Wall and Piece*, 2006.
* Germano Celant quoted in Carol Vogel, 'Next from Christo: Art That Lets You
Walk on Water', *The New York Times*, 25 October 2016.
* Christo is quoted from *The Floating Piers* website: thefloatingpiers.com.

Y Simon Castets and Hans Ulrich Obrist have launched an ambitious curatorial
project called 89plus. There's plenty of information at 89plus.com.
Nicholas Mirzoeff, *How to See the World*, 2015 – a very compelling and readable
guide to how the Internet has radically transformed image culture.
Richard Watson, *The Future: 50 Ideas You Really Need to Know*, 2012. This isn't
an art book, but it's a really helpful guide to the future.

Z Tom Finkelpearl, *What We Made: Conversations on Art and Social Cooperation*, 2013.
Theaster Gates gave a fantastic TED talk, 'How to revive a neighborhood: with
imagination, beauty and art', March 2015. Find it on the app or online.
Nato Thompson, *Living as Form: Socially Engaged Art from 1991–2011*, 2012 –
introduces the work of over twenty artists and curators.

Picture Credits
& Acknowledgments

13a El Anatsui, *Earth's Skin*, 2007. Aluminium and copper wire, approximately 450 × 1000 (178 × 394). Courtesy the artist and Jack Shainman Gallery, New York © El Anatsui

13b Art handlers installing El Anatsui, *Earth's Skin*, at the Brooklyn Museum, 2013. Courtesy the artist and Jack Shainman Gallery, New York. Still from film by Brooklyn Museum © El Anatsui

21 Sloane font pictogram 'No flash photography' designed by Maarten Idema with Lucy or Robert, for Geoff Pickup at the British Museum, London

25 Pablo Helguera, *Unpaid Chief Curator* Artoon. From the series *Artoons* 2008–present. Ink on paper © Pablo Helguera

29 Piero Manzoni, *Artist's Shit (Merda d'artista)*, 1961. Tin can, printed paper and excrement, 4.8 × 6.5 (1.9 × 2.6) © DACS 2017

33 ©Xposure.com

37 Evan Roth, *http://s33.851850e151.244960.com.au*, 2016. Courtesy the artist © Evan Roth

40 Fred Wilson, *Guarded View*, 1991. Wood, paint, steel, and fabric; dimensions variable. Whitney Museum of American Art, New York, gift of the Peter Norton Family Foundation 97.84a d, Photograph by Sheldan C. Collins © Fred Wilson, courtesy Pace Gallery

43 © Guerrilla Girls, courtesy guerrillagirls.com

46 Martin Creed, *Work No. 227: The lights going on and off*, 2000. Dimensions variable; 5 seconds on/5 seconds off © Martin Creed, courtesy the artist and Hauser & Wirth

49 Felix Gonzalez-Torres, *"Untitled" (Placebo-Landscape-for Roni)*, 1993. Installation view of: 'Goldrausch: Gegenwartskunst aus, mit oder über Gold'. Kunsthalle Nürnberg, Germany, 18 Oct. 2012–13 Jan. 2013. Photograph Annette Kradisch © The Felix Gonzalez-Torres Foundation. Courtesy of Andrea Rosen Gallery, New York. Collection of Sammlung Hoffmann, Berlin

59 Jeremy Deller, *Sacrilege*, 2012. Photograph Jeremy Deller, courtesy the artist © Jeremy Deller

63 Michael Heath/*Mail on Sunday*, image courtesy The British Cartoon Archive, www.cartoons.ac.uk

66 Jeff Koons, *Balloon Dog (Orange)*, 1994–2000. Mirror-polished stainless steel with transparent colour coating, 307.3 × 363.2 × 114.3 (121 × 143 × 45). Photograph Christie's Images Ltd. 2013 © Jeff Koons

69 Louis Vuitton Malletier

72 Subodh Gupta, *What does the vessel contain, that the river does not*, 2012. Mixed media, 110 × 315 × 2135 (43.3 × 124 × 840½) Installation view, 'What does the vessel contain, that the river does not', Hauser & Wirth London, North Gallery, 2013. Image courtesy Hauser & Wirth. Photograph Alex Delfanne

75 © RosaIreneBetancourt5/Alamy Stock Photo
79 Santiago Sierra, *250 CM LINE TATTOOED ON THE BACKS OF 6 PAID PEOPLE, Espacio Aglutinador. Havana, December 1999*, 1999. DVD projection (4:3 ratio). Duration 1.00:00. (Lisson inventory ref: SIER990025) © Santiago Sierra, courtesy Lisson Gallery © DACS 2017
83 George Condo, *Power*, 2010. Oil on board, 76.2 × 76.2 (30 × 30). Courtesy the Artist and Skarstedt, New York © George Condo 2017 © ARS, NY and DACS, London 2017
86 © 2016, Herzog & de Meuron Basel
89 Society of Contemporary Art Annual Meeting and Acquisition Vote, May 14, 2014. Photograph The Art Institute of Chicago
93 Tania Bruguera, *Tatlin's Whisper #6 (Havana version)*, 2009. Decontextualization of an action, Behaviour Art. Stage, podium, microphones, 1 loudspeaker inside and 1 outside of the building, 2 persons on a military outfit, white dove, 1 minute free of censorship per speaker, 200 disposable cameras with flash. Dimensions variable. Photograph courtesy Studio Bruguera, Yo Tambien Exijo Platform, Solomon R. Guggenheim, New York. Guggenheim UBS MAP Purchase Fund, 2014 © Tania Bruguera
97 Ulay/Marina Abramović, *Rest Energy*, 1980. Performance for video, 4 minutes, ROSC' 80, Dublin. Courtesy Marina Abramović Archives © Marina Abramović. Courtesy of Marina Abramović and Sean Kelly Gallery, New York. DACS 2017. Ulay © DACS 2017
101 Nam June Paik, *Electronic Superhighway: Continental U.S., Alaska, Hawaii*, 1995. Fifty-one channel video installation (including one closed-circuit television feed), custom electronics, neon lighting, steel and wood; colour, sound, approx. 460 × 1220 × 120 (181 × 480 × 47.2) © Nam June Paik
105 © TDIC. Architect Ateliers Jean Nouvel
109 Yayoi Kusama, *The Obliteration Room*, 2002–present. Furniture, white paint, dot stickers. Collaboration between Yayoi Kusama and Queensland Art Gallery, Australia. Gift of the artist through the Queensland Art Gallery Foundation 2012. Collection Queensland Art Gallery, Brisbane. Photograph Mark Sherwood, QAGOMA © Yayoi Kusama
112 Maurizio Cattelan, *Errotin, le vrai lapin* (Errotin, the true rabbit), 1995. Silver dye bleach print, 183 × 122 (72 × 48) Photograph Marc Domage. Courtesy Maurizio Cattelan's archives and Galerie Perrotin
119 Banksy, Cans Festival, London, 2008
123 © Bianca de Marchi/Newspix
127 © Stephen Wilkes

Acknowledgments

We would like to thank Roger Thorp, Sarah Hull, Poppy David and all the team at Thames & Hudson; Lucy Gibson and Arran Scott Lidgett at EverythingInBetween; Adrian Shaughnessy for his generous help and thoughtful guidance; Ben Wadler and Garam Kim; Fred Wilson and all the artists who feature in this book.

Kyung An would like to thank Ji-Yoon An and Junyoung Kim.
Jessica Cerasi would like to thank Beth McManus and Jocelyne Cohen.

Index